The Interpretation of Pictures

The University of Massachusetts Press

Amherst

Mark Roskill

The Interpretation of Pictures

To my fellow workers in this vineyard

Copyright © 1989 by
The University of Massachusetts Press
All rights reserved
Printed in the United States of America
LC 88-22112
ISBN 0-87023-661-X (pbk)
Designed by Edith Kearney
Set in Linotron Sabon by Keystone Typesetting, Inc.
Printed by Thomson-Shore, Inc.
and bound by John H. Dekker & Sons, Inc.

Library of Congress Cataloging-in-Publication Data

Roskill, Mark W, 1933–
 The interpretation of pictures / Mark Roskill.
 p. cm.
 Bibliography: p.
 Includes index.
 ISBN 0–87023–661–X (pbk. : alk. paper)
 1. Art—Historiography I. Title.
N380.R66 1989
701'.1'8–dc19 88–22112
 CIP

British Library Cataloguing in Publication data are available.

Supplement 1, "Iconography," is reprinted from *International
Encyclopedia of Communications,* edited by Erik Barnouw.
© 1989 by the Trustees of the University of Pennsylvania.
Reprinted by permission of Oxford University Press, Inc.

Contents

Preface

THIS BOOK IS a series of essays on the way that pictures are interpreted. It uses examples, from the Renaissance to the modern period, to bring out the principles and problems that govern the bringing into being of a considered text that, if generally accepted, causes the work of art that is its subject to be viewed in a certain light. Any such text has a specific focus: thematic, structural, or a hoped-for combination of the two. It has as its most basic function the highlighting of certain components of the work, in a way that enhances responsiveness to the roles that they play and so leads to a sense of perception gained as to why they are featured in that fashion. Together, the choice of focus and the highlighting function amount to a presentation of the work in words, contrived so that prevailing or emergent conventions of discourse about visual images impart the conviction of an appropriate and insightful fit between the two.

Do pictures need interpretation? Today, doing this represents a professional field of activity familiarly marked by the presence of conflicting viewpoints and rival ways of proceeding. Selected works are judged capable of being suggestively enriched, in their perceived character, by the projection of alternative meanings onto them. But with no prescribed form that discourse of this kind should take—but rather a plurality of approaches that aim to open the work to the understanding—interpreta-

tion may, more simply, serve as a way of getting discussion going; provided only that institutionalized practices and constraints of the discipline seem to justify such a paying of attention, as opposed to withholding it.

Before the emergence of art history as a discipline in the nineteenth century and its assumption of professionalized lines of inquiry in publications devoted to individual works or artists, interpretation took three expository forms. There was *ekphrasis*, a term deriving from ancient theory of rhetorical persuasion, which in the case of pictures carried the implication of an evocation in words of what the artist had chosen to bring out in representing his or her subject. There was *hermeneutics*, understood to mean (in the older sense of the term) the use of hypotheses about the agency of the artist's inner character and beliefs to determine how the body of his or her work is to be understood. And there was *divination*, which treated images as coded communications like oracular tablets or the sealed books of sects, yielding themselves to the understanding only of those with privileged access to the key.

A leading example of *ekphrasis*, from the mid-sixteenth century, is provided by the letter of Lodovico Dolce to Alessandro Contarini on the subject of Titian's *Venus and Adonis*:

> One sees Adonis moving, and his movement is easy, vigorous and gentle in its temper . . . he turns his face towards Venus with lively and smiling eyes . . . and one has the impression that with wanton and amorous endearments he is comforting Venus into not being afraid. For by way of the serenity of his way of looking and the movement of his mouth he patently discloses the inner workings of his mind. . . . The Venus has her back turned . . . as she exerts herself with both arms to hold him back . . . her look corresponds to the way one must believe Venus would have looked if she ever existed; there appear in it evident signs of the fear she was feeling in her heart, in view of the unhappy end to which the young man came.

This account focuses on what the figures in the painting are engaged in doing and how they are acting; to make the presentation suggestive by rhetorical means, it elaborates on selected features of that presentation that can be taken as conveying its character.

Hermeneutics can be illustrated similarly with key passages from Giovanni Pietro Bellori's late seventeenth-century life of Caravaggio:

Then he began to paint according to his own inclinations . . . he considered nature to be the only subject for his brush. . . . And to give authority to his words . . . when he came upon someone in town who pleased him, he made no attempt to improve on the creations of nature. He painted a girl drying her hair seated on a little chair with her hands on her lap. He portrayed her in a room adding a small ointment jar, jewels and gems on the floor, pretending that she is the Magdalen.

This in turn becomes the explanation of the naturalistic style practiced by the artist's followers: "if they paint armor, they choose to paint the rustiest; if a vase, they would not complete it except to show it broken and without a spout . . . in their figures they pay attention only to wrinkles, defects and skin and exterior, depicting knotted fingers and limbs disfigured by disease." And again, to render the relationship of the art to the person who made it explicit:

Caravaggio's style corresponded to his physiognomy and appearance. He had a dark complexion and dark eyes and his eyebrows and hair were black; this color was naturally reflected in his painting. [In his later works] driven by his own nature he retreated to the dark style . . . that is connected to his disturbed and contentious temperament.

As for divination, it is exemplified in Carel van Mander's 1604 account of the van Eyck brothers and the creation of the Ghent altarpiece:

In the upper part of the right wing, Adam and Eve are represented. . . . Adam's new bride does not offer him an apple, the fruit which artists usually depict for this subject, but . . . a fresh fig—[a] proof that Joannes must have been a learned man. Augustine and other learned men maintain that Eve gave a fig to her husband, for Moses does not name the fruit specifically, and states only that [after the Fall] they covered their nakedness not with apple tree leaves but with those of the fig.

The fruit in question is in fact an Adam's apple, a form of orange shown also on the windowsill and chest in the *Arnolfini Portrait,* but the identification by appeal to a text of Augustine's seemed to settle for the early chroniclers that it must be a fig.

If one moves down in time from those examples to Diderot writing on

Salon paintings in the later eighteenth century, to Ruskin on the Pre-Raphaelites and to Pater on the Mona Lisa in the nineteenth century, what they offer in the way of interpretation could also be taken as instances, respectively, of *ekphrasis*, hermeneutics and divination at work. But something has changed in the interim—in the way the images are read, in the inwardness of understanding implied, in the forms of comparison with other art adduced—that enables us to read into the content of those texts a greater interpretative sophistication. What has happened is that the practices of art history, as understood today, have got under way. They have created a measure of agreement as to what needs to be done procedurally, in the way of gathering the materials together, correlating them with one another and tying them to the historical evidence, before interpretation begins and can take off on its own imaginative trajectory. With the turning of that same agreement into the makings of a discipline, the materials of art history became, during the nineteenth century, progressively systematized: the ways that individual artists treated given stories were classified under the name of iconography; and within the field of style analysis the varieties of configuration attaching to particular cultures and periods were broken down according to representational function and the psychological processing that they called for. Then, with those means of dealing with subject and structure on a comparative basis secured, it became important to be able to enlarge upon the notion of cultural context surrounding the work of art. Ways were sought in which the association with a particular milieu or environment could be fleshed out and given embodiment, in the shape of some concrete connective seen as having a conceptual bearing on the character of the work. Enigma, mystery, spirituality became in this way not just properties of the work, for whoever felt them to be there, but the vehicles of a symbolism that could be elucidated.

Today, with the development of a plurality of approaches within the discipline, an interpretative framework can be found to fit almost any pairing of images that one comes up with. Equally iconography, according to a definition of 1964 quoted in the *Oxford English Dictionary,* has come to consist not just of identifying subject matter, but of "infinitely ingenious interpretation of every picture." But if the role of argumentative ingenuity is so clearly recognized, how is it, one may ask, that art historians appear so little conscious of the fact that words are the medium in which they evoke the character and meaning of images? The answer to this, which has

to do with the rhetoric of persuasion and gaining of assent in the field, forms the subject of Chapter One.

Does art historical interpretation, differ from the interpretation of works of literature in its fundamental premises? Some of the divergencies between the two might be taken as arising from differences in the objects of study themselves. Thus literary interpretation could be thought of as entering into an understanding of the work's structural character in less "immediate" ways, as building correspondingly on a prior, already conceptual apprehension of the way in which particular genres or types of work are to be read. But if all of the varying categories of literature—including drama, poetry, and imaginative historical writing—and the specific kinds of experience that their reception and assimilation entails are taken into account, it seems doubtful that differentiation on those lines can really stand up. Interdisciplinary approaches for their part have been able to bring out methodologically what the two fields have in common, particularly in terms of broad movements of thought or premises of creativity that entail some kind of overlap. But art history has at the same time shown a marked reluctance to assimilate, or even deal with, the tides of critical theory that have marked the development of literary studies in the past twenty-five years.

Certainly the particular interpretative procedures enjoined by that theory—whether it be structuralism, poststructuralism, psychoanalytical theory, newer Marxist analysis, or deconstruction that is in question—cannot be taken over wholesale into the field of art history, which is differently organized in the stretch of its specializations and which has a different set of commitments or traditional practices to hold in mind when explanatory formulations of a historical kind are embarked upon. The ponderousness of the terminology brought to bear and the degree of abstraction from the materials themselves, which has permitted the theory to burgeon of its own momentum, render any such application to the interpretation of the visual impracticable. But an understanding of the revisionary needs to which that theory responded, and the foundations on which it was able to build, are immensely important for a discipline that is, both historically and conceptually, contiguous. One might say further that art history has the benefit of being able to go back, behind the competing and heavily cumbered approaches of critical theory itself, to the strands in that theory that, from the point of view of practical adaptation, are most

amenable to its purposes. Two of those strands, which may be called for convenience the semiotic and the sociological, are woven into the discussion in Chapter Two of the workings of the creative imagination and the communicative ends that, with the help of a rendering into words that is itself imaginative, they may be held to serve.

Pragmatically speaking, a spectrum of approaches to the work of art does not add up to seeing it more completely as it is; nor does any particular approach, even in an ideally comprehensive form, guarantee conclusiveness of interpretation. This raises the question of whether exposure to successive interpretative viewpoints that may be mutually incompatible ultimately enhances understanding, or whether the sheer provocative power of new ideas and personal styles of argument ends up cutting through the "free market" of interpretation like a mystique of privileged insight. Philosophically what is at issue here is whether, in either fashion, interpretation constitutes a way to truth. But, as brought out in Chapter Three, what is regarded as relevant about the work for the purposes of a fitting response to its character not only changes with time; it does so particularly and concretely when it comes to drawing a distinction, for interpretative purposes, between what previously counted as credible commentary and what is now taken as representing verifiable argument. The institutions of art history themselves promote this by developing ways of putting things together about or around the individual work (in the form of catalogue entry, booklet, wall label) that will enlighten some kind of larger public. Contributors to the discipline will then approve particular interpretative strategies and disapprove others from the standpoint of whatever expertise it is that relates them to the institutions of art history, and the purchase that they have professionally as a result on the arguments that go on in the field. They are in this way akin to musical performers whose way of proceeding is vested in what they do and the accomplishments resulting. Like these performers, they feel that they have the work right themselves, even while knowing that others interpret it differently.

In a round-table debate on the justification of interpretative claims—if one imagines such a thing taking place—it might seem clear enough that a relativist who maintains that no absolute criteria can determine the superiority of one interpretation over another might stand opposed to a rationalist who demands that argument take the form of logical and compelling reasons for preferring one alternative to another; and that a

historicist who holds that whatever is read into the past has to be intuitively grasped and synthesized from the perspective of the present would clash with an empiricist who believes in progressively assembling the evidence in as cogent a manner as possible. Those would indeed be possible philosophical positions, each with its own validity of argument reflected, directly or indirectly, in the examples brought up and in what was said about them. But the attainability of truth would not really be what the debate was about except insofar as it suggests the need to open up discussion, in order to take in extrainstitutional considerations of a broader sort. Without such an opening up, truth at any particular time means one thing to those within the profession, and another to those outside. And as with musical performers, it is solely the right of the professional practitioners to their authority that can be contested, depending on how one perceives that it is won or given or exercised.

The present book is the third and last in a sequence of linked publications beginning with *Truth and Falsehood in Visual Images* (1983), written jointly by me and David Carrier, who wrote on his own the second contribution to the series, *Artwriting*, also published by the University of Massachusetts Press (1987). Carrier's input into the planned third volume then turned into another book of his own, to be published separately, while I continued toward a structure that turned out to parallel thematically, chapter by chapter, that of *Truth and Falsehood* and that is similarly based on concrete examples.

The most important motivations for the writing of the book have been to help resolve the present "crisis" of art history by looking back at how the discipline has got into such a situation, or come to see itself that way; and to produce a text about the traditions and practices of interpretation in this field that is neither overly theoretical nor consciously set against theory, but that aims to be clearheaded and to explain key principles and possibilities without resort to jargon. All the disciplines of the humanities, as they have turned in upon themselves, have had the problem of justifying their interpretative procedures, which had previously been accepted as providing common frameworks of discussion for all practitioners, in terms of response to new imperatives, or of choice between rival methodologies. Nonetheless it is perhaps art history that experiences

the greatest divergence between the seeming simplicity of its materials and the complexity of writing about them. If so, it can refresh itself by acknowledging that there is indeed such a gap and by considering what its implications are in terms of the role of rhetoric in interpretative writing, the nature of the language used for characterizing purposes, and the problem of attaining to any ultimate version of truth about a work of art and the relation that work bears to the circumstances of its creation.

Besides basing itself on case studies, from the fifteenth down to the twentieth centuries, this book gives sustained consideration to the work of one particular art historian in each of its chapters—Anthony Blunt, Francis Klingender, Alfred Barr, Jr.—and uses, to match the theme of the chapter, a text of each that singles itself out as largely unlike anything else that he wrote. It also uses the writing of three figures—Hayden White, Charles Rycroft, Dan Sperber—who are deeply involved with critical theory as seen from different viewpoints: respectively, Marxist and other contextualist views of history, psychiatry and psychoanalysis, and structuralism and cognitive psychology; yet at the same time each takes a measured distance from that viewpoint. Again, each of these critical thinkers plays a part in the argument of one chapter. But they have in common that they have all three thought long, hard, and productively about particular case histories; and they conceptualize their approach in clear, unaffected language in a manner that responds to the historical and social as well as intellectual conditions of their time.

In combining these critical arguments, which are unlikely to have a claim on art historians' attention except by special dispensation, with better known materials from within the history of art history that have a particular illustrative force, I hope to create a working balance between the interests of teachers and researchers with an orientation toward methodology and the needs of students seeking an initiation into the present-day state of the field. The adaptation of explanatory principles that apply to different kinds of interpretative writing, and the rescrutinizing of familiar cases from within the discipline may not mesh together ideally for this purpose. But both components are necessary, as far as art history at the present time is concerned, to a venturing into metainterpretation that has both body and breadth.

The first chapter discusses art history as a profession in which inter-

pretation is a basic act, and the terms of discourse that follow from this. It goes from the first bases for exchange between interested parties to the interaction with the materials studied of the point of view and temperament brought to bear, and on to the successful achievement of a consensus, in order to show the relation of the character of the writing to the effect of persuasiveness brought about. The second chapter explores how the discourse of imagination and creativity accords with the assignment of the work to a historical context, both internal and external to the artist's exercise of personality. It suggests how interpretation may thereby bridge the personal aspect of meaning on the one side, and on the other meaning's communal and social aspects. The third chapter reviews the relationship of interpretation to the institutions of art history and their development, especially the museum as a repository of works on display to the public, for which an identity is correspondingly sought. It questions whether there is any given or "core" identity belonging to the art object, apart from interpretations that are given to it from particular viewpoints, with particular audiences in mind.

The present volume may also be seen as a follow-up to the concerns and materials of my earlier *What Is Art History?* (1976). Like that book it excludes the exposition of supporting theory in order to concentrate on a few selected examples. One of my students wittily suggested that I should supply a sequel entitled "What Else Is Art History?" I have not done that, believing that it is not really feasible, in the present climate of critical skepticism and rank disagreement concerning the state of the discipline, to offer broad generalizations about method. But I have responded to the question with a set of essays dealing with arguments that go beyond the most basic concerns of the discipline, and a pair of supplementary texts that comment on the interpretative possibilities presented by the two most firmly established methodological approaches, style and iconography. One of those texts was written for the *International Encyclopedia of Communications* and is reprinted by permission of its editors; the other was written specifically for this volume.

I would like to thank David Carrier and Craig Harbison for the support they have given me by keen critical attention to what I wrote and an ongoing exchange of ideas; Hayden White, Charles Rycroft, and Dan Sperber for the pleasure of talking or corresponding with them; Sura

Levine and Richard Shiff for their extremely helpful suggestions as readers of my manuscript; and Richard Martin of the University of Massachusetts Press for supervising publication of the series that concludes with this book in the most warmly encouraging fashion.

M. R.
April 1988

The Interpretation of Pictures

Chapter One

The Rhetoric of Art Historical Writing:
Emplotment, Tenor, Tropology

A T THE YALE CENTER for British Art in New Haven we stand be-
fore a painting by George Stubbs, from the end of the eighteenth century,
of *Laetitia, Lady Lade.* We are there with a friend who as a professional
trainer of horses is much interested in Stubbs, and in our discussion of
what can be said about his work from an interpretative standpoint this is
one of the paintings that we focus on.[1]

Stubbs has come to be seen in the last forty years as a master in the
representation of anatomy and a keen social observer, rather than simply
a painter of sporting subjects. His output includes subjects of labor, scenes
of social interchange between family members of the kind known as
conversation pieces, and paintings of wild animals, as well as horses with
and without their owners, jockeys, and grooms. There is no doubt that he
was interested in both the marks of human character and intelligence and
the principles of animal locomotion; clearly, from his portraits with and
without animals, he made an intense study of both. A series of exhibitions,
of which we are viewing the latest, has been instrumental in bringing this
out, and the scholarly discussion accompanying them has been part of the
rediscovery of the kind of artist Stubbs was.[2]

Lady Lade is known to have been a skilled horsewoman, and the
question that concerns us in the case of her portrait has to do with the
representation of her mount with its front legs raised. Are we to under-
stand that she is controlling a fractious animal that is acting up, or are the

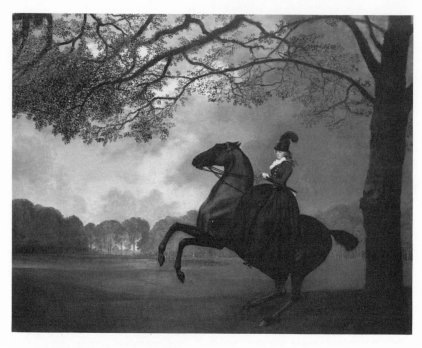

1. George Stubbs. *Laetitia, Lady Lade,* 1793.
Royal Collection. Reproduced by gracious
permission of Her Majesty the Queen.

two of them together performing the movement in dressage which is known as a *levade*? In the latter case, Stubbs would have known how this movement should be done, and it is not being performed here quite correctly. Traditionally, the levade had been used in equestrian portraits as a motif connoting restrained gubernatorial control, and it is possible that its use here for a horsewoman who was famous for her bad language could have an ironic tinge to it; in Stubbs's paintings of famous thoroughbreds, the relative scale and placement of the grooms and jockeys who accompany these animals sometimes seems to raise a similar sort of question as to who exactly is in command. On the other hand, when Stubbs in those paintings exaggerated the natural curve of the horse's neck so that it appears as bent between the third and fourth vertebrae, he was conforming to an artistic tradition at the expense of showing what should be the case, in a racer of superb deportment. So our question leads naturally across to what Stubbs did in the engraved plates of his *Anatomy of the Horse* (published in 1766), and to how he would have regarded critically earlier paintings and prints of thoroughbreds.

For Stubbs's contemporaries and those who wrote about his achievement after his death, either such questions had no force or they simply did not come up. Essentially they offered picturesque anecdotes about the man's personality and his way of working, like those in Ozias Humphry's memoir in manuscript form, based on conversations with the artist and stories related by his widow. Or they retailed and participated in contemporary discussion as to how successful Stubbs was in rendering the actual proportions of a given horse's appearance. Thus Humphry is responsible for putting into circulation the story of how, to create his *Anatomy of the Horse*, Stubbs rented a farmhouse in a remote village in Lincolnshire and rigged for dissection purposes the carcasses that he could obtain there:

> A bar of iron was suspended from the ceiling of the room, by a Teagle of Iron to which Iron Hooks were fixed . . . by passing the Hooks through the ribs and fastening them under the Backbone. . . . the Horse was fixed in the attitude which these prints represent and continued hanging in this posture six or seven weeks, or as long as they were fit to use.[3]

And in John Lawrence's *History and Delineation of the Horse* (1809) one finds, by way of contribution to an ongoing debate:

the artists say that Stubbs saw all proportions through magnifying optics, and that the Crest of the Horse is quite out of nature. . . . With respect to the crest of the Godolphin Arabian, supposed to be overdone by Stubbs and out of nature, the character of the painter may be successfully defended, both from the original portraits, and by a living example from nature . . . a stallion [descended from Eclipse, also painted by Stubbs] . . . with a crest to the full as lofty, swelling and thick.[4]

The difference here from present-day writings can be attributed to sheer lack of sophistication as compared with what came to be expected in the way of commentary in nineteenth-century accounts of contemporary artists, and still more with what holds for today. And to this can be added the provincial situation of the artist. Unlike his contemporary Reynolds, who had a huge clientele and who himself wrote about the artistic ideal that he practiced on a grand scale, Stubbs was producing memorabilia of horseflesh for domestic and connoisseurial purposes. The year after he painted Lady Lade, sixteen paintings belonging to a project of his to illustrate the history of the Turf were exhibited together at the Turf Gallery in London, and the catalogue entries show that owners and visitors were not particularly interested in the artistic aspect. Interest was limited uniformly to the qualities of the horse, its pedigree and history of ownership, and to identification of the figures and landscape settings. It is from this background that there came into being the image of Stubbs as a kind of naive provincial genius specializing in animals. The first attempt at a catalogue at the end of the nineteenth century, in the form of a "List of Known Works" confined to major collections, has an entry for *Lady Lade* consisting of a quite elemental comment on the mode of presenting horsemanship there: the "dashing handsome lady"—it is "not decided [if it be] Mrs. Hills or Lady Ladd [sic]"—is "holding with a tight rein her prancing fiery chestnut."[5]

In the last forty years, in contrast, Stubbs's works have progressively entered that canon of quality and historical significance that (to name, alongside soaring prices, two of the standard tokens of canonization) assures a distinctive place in any public collection and that calls for representative inclusion in a survey history. During this period the materials supporting such a move in the status accorded to the artist have all been gathered and a more or less complete set of illustrations has been

made available. It is on this basis that it has become possible to talk, as we did, of other horse painters as compared to Stubbs, and of the comparative role and significance of Stubbs's anatomy projects.

One way in which to define this shift, as it affects the description and characterization of a work such as *Lady Lade,* is to adopt the term *emplotment,* which has been taken over from Russian Formalist criticism of literature as part of so-called narrative theory in a fashion that makes the term equally applicable to nonfictional forms of writing. This term refers to the ordering of the "raw" materials themselves by a process of inclusion or exclusion, emphasis or subordination, in order to identify how a completed "story" hangs together, and what sort of story it is. In the present instance, the raw materials are the anecdotes or details supplied by Stubbs's contemporaries, and it is their emplotment, aided by a full set of illustrations, that allows one to consider what the pose of the horse in *Lady Lade* means (or connotes, or signifies) and also to ask how the different components and aspects of Stubbs's varied output go (or fit) together. Summarizing, one can say that the shift entails the development of a rhetoric of discussion and argument in which we were participating as we viewed the pictures and exchanged formulations as to their character.[6]

Since that example can be taken as a case of naiveté of response overcome with time and perspective, we take up next a case in which the ordering of the available materials is more simply a matter of selection and arrangement, so that the "story" presents itself as comprising a finite set of events that followed one another in sequence and that led to a particular end result. In the Life of Paolo Uccello as told in Vasari's 1568 *Lives of the Artists,* a five-sentence paragraph is devoted to this artist's monument to Sir John Hawkwood, created for a place in the Cathedral of Florence—in the middle of one wall, where it is to be seen today—to commemorate that English captain who had served in the fourteenth century as a *condottiere* for the Florentines. Though Vasari, according to his normal practice in longer accounts of individual works, goes beyond merely identifying medium, location, and subject and specifying the compositional format and coloring devised for this purpose, to give some characterization of the nature of the monument as an artistic achievement—as a twenty-foot high fresco, it has "extraordinary grandeur" and the representation of sar-

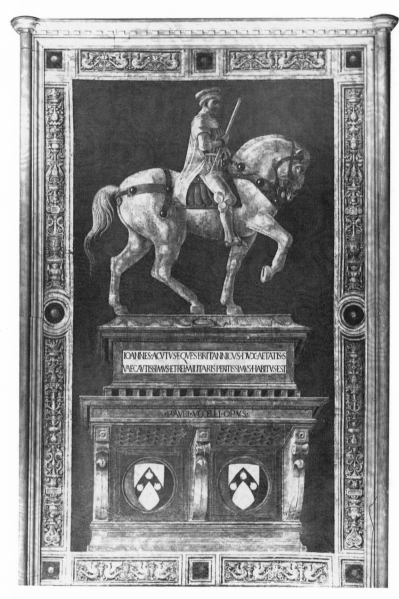

2. Paolo Uccello, *Sir John Hawkwood*, 1436.
Fresco, Cathedral of Florence. Photo Alinari,
Florence.

cophagus, horse, and rider in perspective "has always been regarded as a very fine example of that kind of work"—his is in fact a highly selective description. Though he mentions the artist's signature on the pedestal, he says nothing of the commemorative inscription on the sarcophagus itself. He connects the representation in perspective with a surpassing skill of the artist, recorded separately in story form as amounting to an obsession. And he divines that Uccello simply failed to understand, or allow, that no actual horse could move its legs as shown, "on one side only . . . without falling."[7]

A modern art historian, Eve Borsook, who specializes in Florentine fresco painting, goes further than any of her immediate predecessors in research on this monument and the order of the evidence that she brings to bear. She finds things to say about the character and evolution of the work that not only vastly exceed in wordage the space that Vasari devotes to it but that offer concrete contributions and specifications on each of the three fronts that are subsumed in Vasari's presentation. She identifies the commemorative inscription as deriving in its wording from a panegyric of the ancient Roman general Fabius Maximus engraved on a marble slab (still in Florence today, though it is not clear how it first got there) and imitating classical epigraphy in the style of lettering adopted. She compares the scheme of perspective with Uccello's preliminary silverpoint drawing for it, which happens to survive, noting that the drawing shows the top two-thirds only, with indications of coloring included, and that it is squared for enlargement—the earliest extant example of this practice, which she speculates was learned from the artist's contemporary Brunelleschi. When account is taken of a repair to the sheet, it corresponds exactly, in reduced scale, to the fresco. She also traces possible models for the way horse and rider are shown in earlier equestrian monuments: medieval ones in Venice, which Uccello could have seen when he visited that city between 1428 and 1430; the bronze horses of Saint Mark's Cathedral there; and above all the bronze horse described by Plutarch as put up on the Capitoline in memory of Fabius Maximus, which she connects with the decision to give this fresco the coloration of *terra verde*, imitating the look of bronze with patina on it.[8]

For this purpose Borsook draws on documentary evidence, showing that when in 1433 Uccello won a competition for the execution of the monument, *terra verde* was specified in the contract; and that the actual

execution, which took place between May and August of 1436 (a date that Vasari does not mention) brought the need for a revision on Uccello's part, which she takes to have entailed a change in the perspective scheme. She makes reference to literary texts published contemporaneously in Florence, one of which was a translation of Plutarch's *Life of Fabius Maximus* and the other Alberti's treatise on the practice of painting, which formulated clearly for the first time in writing the method of enlargement by squaring. And she gives supporting technical information, establishing that the fresco is placed now as it was originally, having been transferred to canvas and moved to another location in the nineteenth century, but then moved back to where it had been; and that the present border was not the original one, though there may have been one, but probably was added in the early sixteenth century.

Certainly these details provide us with knowledge about the circumstances of the commission and the processes of execution that are not to be found in Vasari's account. But does this mean that we necessarily know more as a result than Vasari did? Surely not; for however circumscribed Vasari may have been in the primary sources of information and records to which he had access when writing on the art of the past, some sort of "story" of events leading to the production of the *Hawkwood Monument* would have been available to him—with or without specific details and perhaps with other components we do not have—had he deemed it relevant. The perspective studies of Uccello's that he refers to, as forming part of his own album of collected drawings, and the talks with relatives of Uccello's that he mentions could have served to fill out his account here. Instead, anecdotes about the artist's obsession and the characterization of the monument are, in effect, placed on the same level by him: one on which recounting and description take up juxtaposed, alternating roles, as in the telling of the exploits of an epic hero.

Compared to the line of emplotment that Vasari chose to develop for his rhetorical purposes, the argument built by the modern scholar on and around the available facts has, in a case such as the *Hawkwood Monument,* a greater density to it. Within it, the events of differing shape and substance that are marshaled and brought together line themselves up as leading to the end result with what seems like a compressed inevitability. The crucial distinction lies not so much, then, in added knowledge as in the specificity and focus with which this knowledge is deployed, to give

10

the sense of a new purchase gained on what happened, as in the dénouement of a drama of revelation about a set of events in the distant past.

The central task of interpretation is usually taken to be the proposing of meaning, symbolism, or signification. How the details of a visual image are added together, how they are read in relation to one another and to external circumstance are crucial for this purpose. Prints constitute a particularly telling field to be used for illustration here, since their accessibility as images is predicated very often on the inclusion of text inscribed in the work or in a complementary relationship on the same surface; the distribution and exchange of print and text means that the reading of them is supported or enlarged by contemporary colloquy on what they show and how they show it. What Hogarth's prints bring out is that as further "symbolism" is added to what the processes of reading and colloquy can predictably generate of their own momentum, differences of ideological implication introduce themselves into what is said. These implications form part of what will be termed here the *tenor* of the account that is given. Tenor, as used in the theory of communication through imaginative and poetic language (especially the work of I. A. Richards) distinguishes itself from *vehicle*. The substance of what is said provides the vehicle, as most simply in the case of a joke or jest, while the orientation or affiliation of the message thereby sent (recognized when a jest is called barbed, or a joke ethnic) constitutes the tenor. In historical writing the tenor of what is said can be mapped ideologically according to four basic positions—conservative, liberal, radical, anarchic—that correspond to preferences held regarding the desirability and direction of continuity or change in the political and social status quo.[9] In interpretative art history where there is a common ground of discourse, as in the case of commentary on Hogarth's prints, the tenor manifests itself as a coloring to the argument that brings into play for expository purposes one of the same four varieties of ideological preference, without making it explicit as ground for the interpretation.

The print of 1737–38 of *Strolling Actresses Dressing in a Barn* includes several pieces of text incorporated into the paraphernalia of the scene, which are there to indicate or amplify what is going on. The playbills on the truckle bed at the bottom left identify the play to be

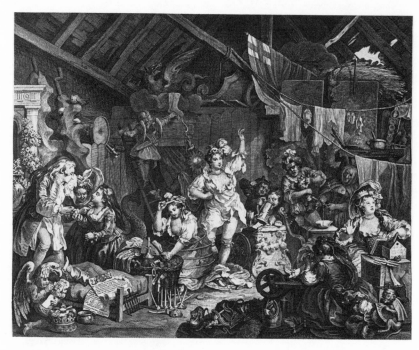

3. William Hogarth, *Strolling Actresses
Dressing in a Barn*, 1737–38, engraving.
Reproduced by permission of The Huntington
Library, San Marino, California.

performed by the company (facetiously entitled *The Devil to Pay in Heaven*) and the mythological roles that are to be played, while draped over the crown lies the statute of the Licensing Act, directed against strolling players, which was put through in June 1737, forbidding them to perform without a license in or outside the City of London for profit. Some of the props that the company has with it are identified by the writings on them (*Oedipus* and *Jocasta* above faces painted on a cloud, *S.P.Q.R.* on one of the Roman banners) as belonging to other plays that they perform. In this setting of crass confusion and interference between activities, "Diana" in the center poses dramatically, but in a state of undress, lacking her bow and quiver and identified only by the crescent on her headdress. A baby being fed is frightened by the costume of Jove's Eagle that its mother wears; "Ganymede," a girl in male clothing, is being given gin for her toothache; "Juno" at the right holds the playbook on a clothes trunk to rehearse her lines. Clothing is being dried or taken down, opportunities taken for refreshment, and so on; appropriately, this image was singled out by Horace Walpole in his *Anecdotes of Painting* as one that "for wit and imagination" ought to be ranked as the best of Hogarth's works.[10]

The Reverend John Trusler, the first to publish a set of commentaries on the prints in 1766–68, shortly after the artist's death, was motivated as a matter of plan to "moralize" what they showed. The radical accent to his moralizing is apparent, in this instance, in his attribution of abject poverty to the players—"we see . . . royalty let down by the ensign of beggary . . . they have but one room for all puposes"—and in his supposition that the "Oedipus" and "Jocasta" above are living people, whose use of the occasion to make love is spied upon by the figure looking in through the roof.[11] George Steevens, providing the commentary in John Nichols's *Biographical Anecdotes* (1781) is more conservative or traditionalist in his emphasis on propriety, specifically rebuking Trusler for entertaining the idea of "some incestuous commerce among the performers." "Surely there is no cause for so gross a supposition," and to arguments of a purely pragmatic kind he adds that incest was "too shocking an idea to have intruded itself amongst [these] comic circumstances."[12] John Ireland in his *Hogarth Illustrated* (1791) makes conjectures of his own, as for example that the figure with the dagger in her mouth attacking the cat's tail may represent Tragedy, rather than the Ghost as had generally been thought; but he does

so in a liberal or laissez-faire spirit, allowing that the juxtaposition of miter and dark lantern on a pulpit cushion remains open as to possible meaning, and consigning the question of whether they could be "symbols of the church . . . designed . . . to hint at the dark cloud which long enveloped the mysteries of religion" to the determination of others more learned than he is.[13] George Christoph Lichtenberg's commentaries, written for a German literary journal beginning in 1784 and reaching this print in the mid-1790s, tend by comparison to deny anarchically any possible source of authority for choosing between alternative allusions: the lantern may go with the Goddess of Night, or belong with the miter, or "Diogenes [may] have left his lantern with the bishop, I really do not know." But where the "easily mistakable and the actually mistaken" are such an evident source of attraction to the inquiring mind, "he who seeks," freed from the constraints of any controlling principle of search, will by his own ingenuity "always find something."[14]

Modern art historians dealing with the same print reveal, basically, those ideological patterns of implication over again. Frederick Antal sees Hogarth as "evoking sympathy for the poor, unlicensed strolling companies put out of business by the Licensing Act," as if he were thereby propagandizing for political reform on their behalf.[15] Ronald Paulson takes the print to be a statement of "the metaphor of life as a stage," thereby removing it from any connection with the risk or threat posed by the Act that could pass for radically critical, into a more traditional and affirmative dimension of allusive reference, where it becomes a comment on society as a whole rather than on "the actresses themselves as people [and] their pretensions."[16] Lawrence Gowing labels it "a parody of a grand baroque decoration"; which one is left unspecified, as if to defend the liberty of each individual interpretation to develop its own rationale as to how the parodying works.[17] And most recently Shaun Shesgreen sees the satirical impulse in Hogarth as moving here in multiple directions, "antipastoral and antimythological," taking as its running targets the corruption of the City, Palladian architecture, mythological painting of the seventeenth century with its content of "courtly allegory," and traditional imagery of the Four Elements; in drawing upon "models" for purposes of social satire and at the same time demolishing them by removing a sense of the "alluded-to" as an ideal, Hogarth "subverts

iconography rather than building upon it."[18] The same alternatives in ideological tenor repeat themselves, then, even in order of succession. The differences are, first, that there is a greater self-consciousness in the modern writers as to whether such differing interpretations are or are not compatible with one another; and second, that they tie their analyses together more explicitly with those that they make of other prints: the *Southwark Fair*, which also has a theatrical theme, or the *Four Times of the Day* with which the *Strolling Actresses* was joined to form an ensemble of five prints in the publication announcement for it.

Whereas Stubbs's paintings were to be looked at in an open exhibition or club showing, and the Uccello was to be seen in the Cathedral of Florence as it came into being, modern works of art were very often not created for public viewing, and received this only when they entered the context of a museum or were accorded the status in retrospect of being culturally significant artifacts. This means that the kind of colloquy that Hogarth's prints were guaranteed at their appearance, in coffeehouse and shop window and before a socially mixed audience, is simply missing in cases of this latter-day kind. At most there would be the response of a few friends and supporters, whose suggestive remarks and writings on the artist and his or her culture have a rationale of their own for their existence. But the absence, beyond that, of comment on particular works would be like a surrounding silence, and the question then is how that silence may be filled. There are three ways in which one may conceive of doing this for explanatory purposes: by reference to what differentiates the work from other contemporary productions whose imagery, processes, and patterns of interaction with their audience may shed light for comparative purposes on what is special in this case; by reference to other preceding and subsequent works of the artist and their evolutionary relationship to this one; and by reference to the cultural context of the work's production, including both intellectual ideas in the air at the time and concepts or models of artistic practice that can claim to have had an affective role. Here the tenor of the interpretative presentation moves to being not just an ideological coloring or overlay, but the style of argument of a more encompassing sort that is adopted for explanatory purposes.

In the representative case from the modern period of Picasso's *Portrait of Daniel-Henry Kahnweiler* (1910), which has for subject the artist's dealer of the time and which did not have the benefit of a public showing till much later, an "intentionalist" argument will be one that respects the fact that there are no recorded comments of the artist bearing on the work, nor any contemporary discussion of its coming into being and reception. Whether the "intentionalism" focuses on the working of the artist's mind here and at the time, or on a reconstruction of what may be called the direction of endeavor, in which function and underlying aesthetic are subsumed, the argument begins from the need to compensate for that absence. Most especially, in the version that has become familiar in the writings of Michael Baxandall, it asks what kind of activity in the construction of an explanatory text about the work would be reasonable in those circumstances.[19]

Two observations about the *Portrait of Kahnweiler* are immediately relevant here. First, the geometrization of planes and angles throughout and the bleeding out that takes place toward the edges would seem to stand in the way of responding to the work as a portrayal of a historic individual (whereas height, placement, and framing in the *Hawkwood* assist this). If we do take it as a portrait, in the sense of a study from life of a particular physiognomy and personality, we may be able to see (for example, by comparison with a photo of the man) that certain physical features are emphasized and singled out, and the same with the contents of the setting, which are again hard to make out. So we can infer from this that Picasso treated Kahnweiler for the purposes of this presentation as an available model posing in his studio, and with that indication and the relationship it sets up to other works of the same period, the spatial and atmospheric treatment of the surrounds becomes suitably conformate—though one may also wonder why, if important enough to be singled out, particular elements in these surrounds are not shown more identifiably.

Now comparison of portraits roughly contemporaneous to this one, by the so-called Salon Cubists such as Delaunay, Gleizes, and Metzinger, suggests that in the milieu of cultural exchange that those artists and Picasso shared, terms of discussion were available that can serve to clarify and bring into focus, on two separate fronts, an "intention" appropriate to the character and genesis of a portrait that looks as this one does. Such assumed discussion of the time would postulate or draw attention to the

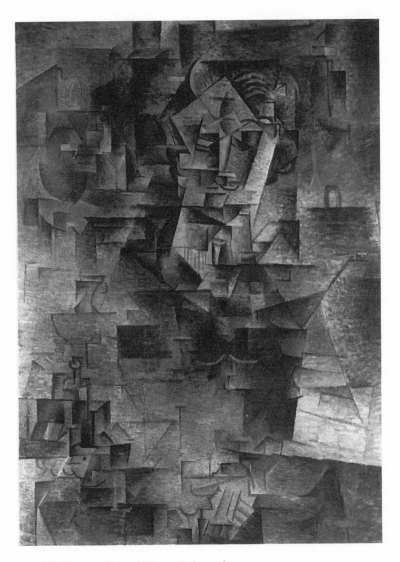

4. Pablo Picasso, *Daniel-Henry Kahnweiler,*
1910, oil on canvas, 100.6 × 72.8 cm, Gift of
Mrs. Gilbert W. Chapman in Memory of
Charles B. Goodspeed, 1948.561. Courtesy of
The Art Institute of Chicago. Copyright ARS
N.Y./SPADEM, 1988. All rights reserved.

more private character of the transaction in this case between artist and subject; and it would conceive of what was done to the image as less deliberately planned or more improvisatory in character, so that that image belongs in a more ongoing and self-referential pattern of creativity.

This version of an "intentionalist" argument, as put forward by Baxandall, contrasts very evidently with preceding interpretations of Cubism that have set out to explain the character of the *Portrait of Kahnweiler* by modes of analysis that derive justification for their use here from being established as conventionalized strategies within the modern discipline of art history. The formalist approach, in order to bring out the particularity or uniqueness of the individual work of art with the aid of identifying labels, relates it to other works in sequence, while the contextualist approach seeks to explain artistic "events" within the context of their occurrence, by relating them to other happenings in the surrounding field.

Thus the formal interpretation of the *Portrait of Kahnweiler* offered by John Golding is that the reintroduction of naturalism in the proportions here, compared to the paintings done at Cadaqués in the summer of 1910, and the "more realistic touches" in the coat, lock of hair, and still life served to solve the problem that Picasso had at this particular time of keeping in touch with the visual reality of his subjects. And in Douglas Cooper's extension of the same line of argument the interpretation becomes organic in character, in implying that a synthetic process of an integrative and consolidating kind is at work here, which crystallizes the treatment of the subject into something more than the sum of its parts. A "strength of will to keep in touch with reality," as Cooper puts it, is implied in the steps taken to "make particular features identifiable and provide clues to the build-up of the composition as a whole," so that the painting should not become "wholly abstract and non-figurative."[20]

The contextual interpretation of the same work hinges, as in the discussions of Edward Fry and Roland Penrose, on the identification of the objects to be made out at the upper left as two pieces of New Caledonian sculpture recorded in a photograph of two years earlier as hanging in Picasso's studio. Picasso's ownership of those sculptures both elucidates what is shown to the side, and also makes it part of the historical "scene" leading up to the creation of this painting that he should be in touch with the character of primitive art objects that he then, in his role as agent,

draws on or responds to in predictable ways—here, by giving the effect in the rendition of nose, eyes, and face of an "anthropomorphic architecture" that unlike the relative identifiability of shirt, collar, tie, and watchchain is "detached from representation," and yet achieves a quality of "mysterious likeness." The process of argument even becomes mechanistic in its assumption that facts discovered in the historical field can be taken as holding causal responsibility for processes leading to specific outcomes. Kahnweiler's habit of keeping medicine bottles beside him accounts determinatively for the presence of a "group of bottles" on the table at the left, and the presence on the wall of the Oceanic sculptures engenders the displacement of Kahnweiler's head off-center, so that a "witty juxtaposition" of one to the other may occur.[21]

Compared to those forms of interpretation, shaped by the guiding suppositions of purposiveness on the one hand and of causality on the other, the line of argument considered first puts its emphasis differently. In order to develop an explanatory text, it moves obliquely to the conventions of discourse germane to the viewer of that time and place, and then back to the artist and his address to the viewer who verbalizes in such terms. But this leaves open the question of whether the conditions and constraints placed upon readability in the *Portrait of Kahnweiler* are ultimately self-defeating as far as communication of an informative kind is concerned, or whether the play with devices of representation and reference belonging to traditional artistic vocabulary is so undercut by incompleteness and inconsistency here that the burden of finding significance devolves as a direct consequence onto the viewer's responses.[22] The reason for this lack of transparency, or ambiguity—terms carried across from the understanding of human actions that may or may not similarly be accompanied by words—is that at the point in time when they were becoming constituted as accepted principles of art historical practice, the methods of structural analysis and cultural contextualization developed by Riegl and Warburg early in this century were being undermined by the character of the art that was currently coming into being. The very idea of reconstituting mental states of the artist was shaken as a result, and a consistency of intention became hard to maintain when what was entailed in the creation of a work such as the *Portrait of Kahnweiler* might represent a provisional and empirical testing of the waters. So Baxandall's

move does not solve the problem of explanation in the way that more traditional frameworks of art historical interpretation can claim to do.[23]

In recapitulation, then, the forms of emplotment by means of which art historians select and organize their materials into a narrative framework, the ideological tenor and style of explanatory argument brought to bear in their respective interpretations all make for difference between one writer and another in the rhetorical character of the texts that they produce, as well as between periods. How then, within the writing of art history, is agreement reached, or assent to a particular set of interpretative findings arrived at?

It might be expected that those factors and forces that make for acceptance in the scientific community of new discoveries, both fresh ways of seeing and original concepts would also have their application here. On that model, art historians' interpretative claims about their data—the works of art—would derive their convincingness for others within the discipline from three directions: (1) the validity of perceptions gained by direct scrutiny of the work; (2) the power of insight offered into the creative processes as they shaped the character of choices and decisions; and perhaps the most crucial, (3) the provision of a theoretical framework of understanding that proved productive in the way that it caused the evidence to be viewed. Ernst Gombrich's book *Art and Illusion* (1960) is an example of an art historical text with many individual passages in it that in this quasi-scientific sense can claim "originality." Gombrich points out, for instance, that behind the organ of the music-making angels in the Ghent Altarpiece there can be glimpsed "the garment and hair of the angel working the bellows, which Jan van Eyck did not want to miss out." He draws attention to the faces in the clouds in Mantegna's *Virtue Chasing Vice* (which had again apparently not been noticed before) and suggests why Mantegna chose to do this: to show "his interest in the workings of imagination," he "mak[es] us see [those] faces." And giving consideration to a series of drawings by Constable—previously unpublished, because they seemed uninteresting—in which cloud formations are freely transcribed from a pattern book of Alexander Cozens, he interprets them, in the light of his general theory of "making and matching" and its implications for the understanding of copying, as showing that Constable learned

from Cozens "a series of possibilities, of schemata, which should increase his awareness through visual classification."[24] These findings are subject to confirmation, like those of the sciences, by the use of more exact instruments than the naked eye, by the addition of further data or the enlargement of the sphere of evidence brought to bear. But they also form part of an argument on a very broad theme, the psychology of pictorial representation, and serve as illustrations to it, each for its own purpose. If they do not necessarily reappear in the subsequent literature on van Eyck, Mantegna, and Constable, this may be because they are not entirely detachable, in terms of relevance and cogency, from their place in that argument. They may also have won a tacit acceptance that does not require repetition, like the examples illustrating a theory in general text-books.

But what one finds contrastingly, in the case of the establishment of Poussin as a learned artist, is that persuasiveness in building up a case depends (as with Homer, the Bible, or Shakespeare) upon communicating a mastery of the existent state of knowledge that is here more complex; and that the argument, rather than being of a piecemeal sort, like the tradition of juxtaposing selected works for comparative purposes that Wölfflin inaugurated, is one that can be applied to the oeuvre as a whole, in order to "map" Poussin in a coherent fashion onto this particular territory of artistic achievement. Anthony Blunt's success in bringing this about with his book on Poussin published in 1967 (presented initially as lectures in 1958, in the same series that had given birth to *Art and Illusion* a year earlier, and then much revised for publication) was so complete, in the degree of authority and convincingness with which it vested his interpretation of the pictures, that it is worth examining in detail.[25]

Blunt started out in the 1930s by editing Poussin's extant writings and ideas on painting, which gave him a familiarity with the kind of thinking in verbal form to which Poussin's mind lent itself.[26] He was to characterize that mental disposition, as he came to know it, in terms of consistency of outlook as well as rationality. Here he differentiates himself already, in the bases of his assessment, from eighteenth- and nineteenth-century commentary on Poussin, both English and French. Sir Joshua Reynolds in his Fifth Discourse (1772) had intuited from the copies of antique works of art known then as being from Poussin's hand, and from what he termed the "dryness of manner" in the middle period paintings,

that Poussin had the aim of bringing to mind the look of ancient art, in execution as well as choice of subject; while French critics of a work such as the *Death of Eudamidas* had held that the combination of economy of means with rigor in the treatment of expression and overall mood, though morally effective, was likely to produce an insufficient explicitness.[27] Citing Reynolds only once in his book, and then briefly, on Poussin's possession of a "mind naturalized in antiquity," Blunt came to see it as almost self-evident, from closer and fuller knowledge of the paintings (as opposed to engravings, which served in earlier times as the main means of enhancing understanding) and from secondary and supporting evidence not then available, that the depth of absorption of antique source materials entailed their transformation, and that the imaginative quality of design, which became a focus of admiration in the nineteenth century, was capable of producing "deeply moving qualities" rather than a cold unemotionality.[28]

Blunt did not argue with those predecessors. In work that he did on the drawings, and in a long series of articles on individual topics that he later christened his "Poussin Studies," he moved toward what he then conceived of as a monographic study. For this purpose he revised, corrected, or supplemented earlier opinion on individual works; his only public quarrel that found its way into print was over the chronology of the early paintings. At the time of the major Poussin exhibition held in Paris in 1960, which provided the occasion to bring his work on the artist to a climax, he contested the dating scheme proposed by Denis Mahon—who had claims to being his only rival as an expert, at least in England—advocating instead the "flexibility" and "remediability" of a "loose system of chronology" that allowed in his view for the contending claims of logicality and illogicality in the way that artists actually performed.[29] The most celebrated view of Poussin's art as a whole preceding his, that of Roger Fry claiming (in *Transformations*, 1926) that Poussin's primary concern was with formal or "purely plastic" considerations, he simply treated as unhistorical. He placed a long passage of Fry enunciating this view at the start of his book, in order to point out that it was "bad luck" that the painting that Fry singled out for discussion in those terms, the *Achilles Discovered among the Daughters of Lycomedes* presently in Reims, was "now universally dismissed" as the work of an imitator. How-

ever, that same attitude was to be found less explicitly in Fry's statements about other, "well-established works" by Poussin.[30]

The development of Blunt's contrary contention, about the importance of "meaning" in Poussin's art and its central role in shaping the choice and presentation of the subjects that appear there, went back to one of his early articles, on the "heroic" and "ideal" landscapes, published toward the end of World War II. First adumbrated there, this view of his was built up gradually over time, to culminate in a paper on symbolism in the late works that was read to the 1958 colloquium of Poussin scholars in Paris.[31] As he acknowledged in the preface, his book drew particularly on a suggestion of Walter Friedländer, in his 1914 monograph on the artist, about Stoic themes in the compositions of the 1640s. Blunt was one of a small team that worked collaboratively at the Warburg Institute in London on the eve of the war on a plan that Friedländer had brought into being for a general book on Poussin's draughtsmanship, which would include considerations of theme.[32] Another guiding contribution that he named to the formation of his view came from an article that Gombrich, who had joined the Warburg also in the prewar years, published in 1944. Gombrich suggested that the representation of Orion, in Poussin's painting of that name, drew on an allegorization of the basic story that was provided by the sixteenth-century writer on mythology Natale Conti.[33]

Though he did not put it this way, Blunt was in fact combining and synthesizing for his purposes different approaches to the question of "meaning" in works of art that had come to be practiced at the Warburg Institute in the years following its transfer from Hamburg to London. Contextualization represented, as stated earlier, one of the leading strategies of explanation that became established early in this century and that opened to expansion as a key component of the modern discipline of art history. Blunt contextualized Poussin's art along lines of investigation that were familiar at the Warburg Institute during the period of his attachment to it. The work of art could be studied in a context of humanistic learning that included the explication of religious and philosophical texts, and such explication could be taken as bearing on the changing ways in which a "story" (biblical or mythological) was depicted in visual form, and on the levels of understanding that were engaged in the contemporary viewer's recognition of that story. Through access to the climate of thought sur-

rounding the work or the governing ideology of its time, reference can be taken as being made to an informing concept or idea that is not given visible presence in the work (as in the case of allegory), and the symbolic elements of this sort can be seen accordingly as adding up to a larger web or pattern of meaning. Equally, in the light of the way in which the components of the visual language adopted achieve adaptation so that they come to signify in specific ways, resonances of subject matter and suggestive qualities of presentation may be regarded (as in popular forms of imagery) as the carriers of sociopolitical implications and psychologically charged nuances corresponding to developing forms of consciousness of the time. The assemblage of visual components and the structure of the work as a whole can thus be analyzed alongside, and set in relationship to, the identification of reference to existing visual images or to visual traditions more generally.[34]

Blunt became adept at working in all these fields of investigation. Already while researching at the Warburg Institute he developed his early study of Renaissance art theory for publication in a fashion that stressed the humanistic context in which those writings on art were generated and accorded notice. He wrote on the symbolic ideation of an image of Blake and the allegorical implications of El Greco's *Dream of Philip II*. Having chosen to study with Frederick Antal, he was made conversant, in pursuance of Marxist lines of thought, with the role of art as an agent in the development of political and social consciousness.[35] But the shape of his lifetime career has a more extended bearing on the way in which he presented Poussin's art.

Early in his monograph Blunt fashions a picture of Stoic inspiration in which Poussin's deep absorption of humanistic ideas calls for a matching level of understanding of its role in the paintings. Not only does the middle period of Poussin's art make use of many themes from the Stoic historians, but Poussin's letters are also replete with phrases taken from them. Therefore, Blunt says,

> It is fair to conclude not only that [Poussin] was well versed in their ideas but that he regarded Stoicism as a guide to the conduct of his life. Naturally, Stoicism would not account for the depth of feeling apparent in Poussin's religious compositions, but it can be shown that he was interested in the doctrines of certain early Fathers who evolved a synthesis of Christian

24

theology and Stoicism. . . . Further, the conception of man's relation to nature as set forth by the Stoics can explain much that is puzzling in Poussin's great landscape paintings of his classical phase; and finally, Stoical ideas lie behind those magnificent late works in which Orion and Bacchus and Apollo play the principal roles . . . for they seem to be based on the ideas of late Stoic writers like Macrobius, who saved the tottering myths of Greece and Rome by converting them into allegories illustrating the nature of the universe.[36]

In other words, Poussin's involvement with Stoic thought is proved by these links to have had a profound effect on him, especially late in his career. If we were to apply this model of reasoning to Blunt's own life, in terms of religious and intellectual patterns of thinking that he absorbed, it would have an odd ring. A clergyman's son, Blunt belonged while at Cambridge to the Apostles' Society, which traditionally favored moral free-speaking and -thinking, and was exposed at that time to Communist ideology and recruited into its service. There are some possible reflections of these aspects of his life in the way he discusses Poussin, as when he remarks on the tone of flippancy or levity in the artist's letters when it comes to religious matters; comments on the *libertinage* current in Poussin's circle of friends and patrons in Paris as entailing rationalism and a personal ideal of a virtuous life; and stresses that Poussin's patrons in France were bourgeois rather than noble. But the argument from the letters to the paintings suggests that it was the "cool detachment" of personality and the accompanying effect of "masking" that Blunt was responding to psychologically in Poussin, rather than the deeper affect of the ideas themselves.

The idea of a web of meaning of an allegorical sort governing the work as a whole is similarly apparent in the discussion of the late series of the Sacraments. Blunt defines Poussin's conception here as "erudite, allusive, almost abstract," in contrast to Carlo Maratta's drawing of Confirmation showing this sacrament as "an everyday scene in contemporary dress" according to the "manner handed down in traditions of engraving." In his summation, the conclusion to be drawn is that

Poussin aimed at creating a version of the theme which was in accordance with the liturgical and theological principles of the early Christian apologists, and there may be in some of them allusion to the Mysteries of the Greeks or the religion of the Romans. There is certainly about all of them, particularly

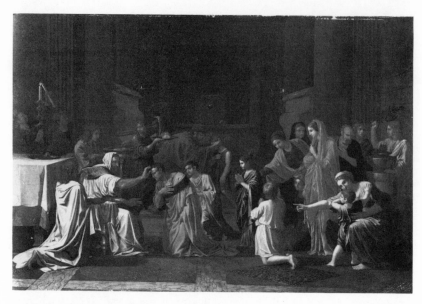

5. Nicolas Poussin, *Confirmation*, from Seven
Sacraments series, 1644–48. Duke of
Sutherland Collection, on loan to the
National Gallery of Scotland.

the second series, a very strong flavor of classicism, due to the artist's careful study of ancient models.[37]

Blunt had earlier compared catacomb frescoes and early Christian sarcophagi, in order to establish such study on Poussin's part, and he takes the structural features that reflect this as being part of the same larger pattern of meaning that the choice of themes invokes. This is the side of his personality at work that engaged in "collecting and sifting of the material," those being the terms on which Blunt contributed to the first volume of Friedländer's project for publication of the drawings; with the later volumes his role became more strictly editorial, and now supervisory of the overall plan.

As to how exactly Poussin had access to the philosophical and theological values in question, Blunt suggests, in support of the other two arguments also, that the special meaningfulness of those ideas to Poussin can be objectively established. To the objection that Poussin as painter is "unlikely to have bothered his head about . . . fine points of theology or, indeed, to have been capable of reading the Fathers [of the Church]," he responds by observing that the case he has already made for knowledge of late classical texts in the fields of mythology and history "seems to point in the other direction." He then goes on to marshal the evidence that the people in whose circle Poussin moved in Rome and the patrons for whom he worked there were "deeply versed in such matters." This evidence included Cassiano del Pozzo's study collection of drawings made from classical sculptures and early Christian antiquities; Cardinal Camillo Massini's library of books and manuscripts which, Blunt affirms, "Poussin must have used freely," as he was both a friend and a patron, as well as his art collection; and also Cardinal Francesco Barberini's library, rich in books and manuscripts of classical and early Christian authorship, which Poussin could have consulted with the help of the cardinal's librarian Holstenius, himself a specialist in the early Fathers and Byzantine history and composer of a treatise on the sacrament of Confirmation. Thus,

> with patrons like Pozzo and Massini, with libraries like the Barberini, and advisers like Holstenius, Poussin was in a good position to get any information that he needed about questions of theology, philosophy, liturgy or archaeology; and from what we know of his intellectual inclinations [and here Blunt cites the firsthand testimony of Bellori in his early biography that

Poussin was well read, not only in the subjects with which he was directly concerned, but also in "the liberal arts and philosophy"] he was the kind of man to take advantage of his opportunities.[38]

During the war Blunt had served in a branch of military intelligence, and the argument from access and for a special depth of interest in certain materials that he mounts here is very much like that of the intelligence expert. The latter comparably works from knowledge of a network of contacts, and from possibly suggestive or corroborative evidence that is to be found in the files on particular people or projects. The "hard line" attitude toward sources and documents assimilated in this way was confirmed art historically by Blunt's association with Johannes Wilde, who had been a Communist in his youth in Budapest and a subsequent victim of Nazi persecution, and who was interned by the British government during the war. Blunt was drawn to him personally and to the positivism and formalistic approach that Wilde practiced: search for the exact visual source, explanations of development geared specifically to the available documentation. In this way he imposed, with Wilde's backing, a concretized version of the British (and more specifically Cambridge) tradition of empiricism in which he had been formed intellectually—arguments about sources and contextual influence had to have an effect of closure, as opposed to the more expansive type of investigation that Warburg and Saxl had favored.[39]

On the question of whether Poussin's paintings evince, besides learning, any personal religious feeling, Blunt equally comes down firmly in favor of ascertainability. After reviewing at the start of his chapter on Poussin's religious ideas the various rival suggestions that have been put forward here—that Poussin was influenced by Jesuit ideas, that he was connected with the Compagnie du Saint-Sacrament, that he was affected by Protestant doctrine, or that he was a *libertin*—he ends by saying circumspectly that "there is a certain truth in all these suggestions, but none of them is entirely satisfactory." Presumably they are not entirely convincing in terms of what they claim to explain in the paintings, or in their linkage to the art as a whole; or certain details in them (as Blunt says of one such suggestion) are "open to positive objection"—all these comments are in line with the making of qualifications on an intelligence report. "They all however," as Blunt puts it, "have one feature in common,"

28

namely that Poussin was not in sympathy with the Catholicism current in the Rome of his own day, to which Bernini gave the finest expression; and indeed *this fact at once becomes apparent* [our emphasis] if we examine Poussin's few comments on religious matters in his letters and above all if we look at the paintings themselves.[40]

But how much can actually be "told" from paintings about their incompatibility with particular religious ideas, or a particular political and social stance? In his own case it is apparent in retrospect that, while he was writing the Poussin book, there was the image that Blunt presented to the world as Director of the Courtauld Institute and Surveyor of the Queen's Pictures; and there was the conflicting and dividing pressure put on him by the fact that he was at the same time open to exposure as having served as a wartime informant to the Russians. But even for those who suspected or heard word of the latter activities, nothing in his public person and professional roles betrayed an open conflict, or rendered his sympathies accessible. With paintings as opposed to persons, the caveat on this score, even about the use of inference, must be even stronger.

Certainly the claims of a historical interpretation are ones that circle back from the materials used in the emplotment, and the type of argument brought to bear, to the position and authority of the person making the interpretation. But granted that there can be found in Poussin's art the hallmarks of an attitude toward order and tradition to which Blunt was drawn, and to which he developed a life-long attachment, the question remains as to what made his mode of presentation appealing, so that those hallmarks appeared as convincingly "there" to the assenting reader. Here we must look to the very way in which, to identify those hallmarks and give them existence, words are applied to the paintings. All art, inasmuch as it constitutes a form of figuration, is built around sign, metaphor, and allegory; and the art historian matches this fact with a form of presentation, to be called here a *tropology,* in which each implicitly or explicitly plays a defining role. From an interpretative standpoint, a focus on signs represents a way of dealing with the issue of reference in visual imagery; recourse to metaphor represents a matching in words of the poetic or imaginative character of an artistic creation; and the adoption of allegor-

ization represents a way of communicating (by the devices of language) what is not expressed directly (by the object under scrutiny). Interpretative communication is correspondingly grounded, precognitively and precritically, in the linkages in these senses of word with image; the way the linkage is made identifies conceptually the character of the elements in the field of study that are to be considered in their relations to one another. Structurally, the linkage identifies the character of the verbal model that is to be used to give a historical account that represents and explains those elements.[41]

In the tradition of the Warburg Institute that was described earlier and that Blunt thoroughly assimilated, signs represent, very generally, arrangements and orderings of imagery that can be elucidated in the light of texts, or alongside texts; metaphors are transformations of an existent or inherited language of expressive communication; and allegories represent ways of communicating the connections of the artwork to the surrounding humanistic and religious culture. In Blunt's *Nicolas Poussin* that model becomes more narrowly and determinatively focused. Signs are the indicators of a demonstrable learning in Poussin; because of deliberation and order in the artist, they can be assembled and elucidated. The tokens of Poussin's attachment to classicism are like metaphors; Blunt calls them at one point "philosophical signposts" (*Nicolas Poussin,* 203). And allegory carries the intimation, especially in the late works, of Poussin's access to a privileged circle of initiates.

Gombrich in his earlier years at the Warburg Institute worked in that same tradition, seeing that model as flexible enough for his and the Institute's purposes, so that his study of Poussin's *Orion,* which Blunt acknowledged in 1958 as contributing directly to his view, represented simply one among an expansive set of possibilities.[42] In his *Art and Illusion,* contrastingly—to take up again the illustrations to the argument that were singled out earlier—he effectively purified the sign so that as part of a general shift to "beholder's attitude" it becomes an image standing in abbreviated form (because the achievement of illusion is necessarily incomplete and selective) for its counterpart in the real and visible world. In our impression or belief, in front of the Ghent Altarpiece, that Jan van Eyck "succeeded in rendering the inexhaustible wealth of detail that belongs to [that] world," including "every hair of the angels," we observe or accept that "a glimpse of red and brown" behind the organ

represents the garment and hair of the angel working the bellows.[43] Metaphor, as in the case of Mantegna's clouds, entails the drawing of an analogy or finding of a resemblance that evinces the artist's desire to impress on the viewer the relationship that he sees.[44] And allegory entails a process of recasting, by transposition or substitution (as with a code), in order to go beyond existing patterns of truthfulness in representation. Constable, as he puts it, "does not merely apply [Cozens's schemata] in his searching study of phenomena, but articulates and revises them beyond recognition," thereby making his versions of cloud formations into an allegorization of his competition with convention, in order to excel.[45]

Both Gombrich and Blunt can now be compared, in the positions they take here, with what is to be found in art historical writings of more recent vintage, by Leo Steinberg and T. J. Clark. Steinberg and Clark equally enunciate discoveries of theirs and bring in the creative processes of the artist; but they do both of these things, and more generally see the issues of human and moral concern to which the work of art gives expression, from an explicitly modern standpoint, over which they argue with their predecessors.

In Steinberg's *The Sexuality of Christ in Renaissance Art and in Modern Oblivion* (1983) signs consist of conventions of representation that are converted so as to take on a novel meaning, in a context that is at the same time "part of common creed." Thus Christ's penile display is "a sign of the Creator's self-abasement to his creature's condition." Metaphors represent ways of expressing an unusual personal perception or response: Roger van der Weyden's "efflorescent" treatment of the humble loin-cloth turns the *ostentatio genitalium* into "a fanfare of cosmic triumph," and the chin-chuck, by analogy drawn, in words of Saint Bernard that are quoted, "from the things we know" is converted into a "visual text with both literal and mystical connotation." Allegories are the embodiment of quintessential human and existential truths to which artists responded; in Steinberg's words, "a new iconography [in the Renaissance] that is neither narrative nor iconic but [that consists of] historiated emblems designed to enshrine the central mystery of the Creed" gives rise to "signs of instant maturity [in the Christ Child] nothing short of miraculous," and to the "theme of prolepsis" whereby "objectively . . . Christ's whole destiny is engraved in the Incarnation, subjectively . . . the boy is understood to foreshadow his death."[46]

In Clark's *The Painting of Modern Life,* on the other hand, published almost contemporaneously, signs are pointers to what was found rebarbative in the art of Manet and his followers, by contemporary criticism and audience response. The hand of Manet's *Olympia*—called "shameless, flexed, in a state of contraction, dirty and shaped like a toad"—stands for Manet's disobedience to the "rules of the nude," and hair and hairlessness in that painting are a "second sign—a strong one—for much the same thing." Metaphors represent what favorable critics could respond to in equivalent form, or what is parallelled at the time in terms of literary effect: on the one hand the "fretting yellow fringe" hanging from Olympia's pillow and the "factual repetitive rhythm of work that [Monet] is trying for" in his *Men Unloading Coal,* and on the other the melancholy of the *banlieue* as evoked by van Gogh in his Paris years and by Zola in his *Les Misérables* (1861) or the qualities in outdoor impressionism that Jules Laforgue characterized when he wrote in 1883 "No more isolated melodies, the whole thing is a symphony which itself is life, living and changing." Allegorization inheres in the treatment of the landscape, and figures in relation to it, as an expression of the social conditions of the time. Manet's 1874 painting of *Monet and His Wife in His Floating Studio,* for example, "might be read as a kind of reflection of what it meant to keep hold of [the] category [of landscape] in a place like Argenteuil." It meant "contriving to notice some things that loomed large in one's field of vision and to overlook others just as prominent" [especially evidence of industry] and doing so more emphatically than before, "more wrapped up with the matter in hand."[47]

Thus in art historical discourse the concept of signs that the writer uses expresses his or her attraction to a certain type of elucidation. The concept of metaphor adopted epitomizes a philosophical viewpoint to which he or she is drawn. And the conception of allegory embodies the shape of the writer's own relation to his or her culture and background. From this combination derives the tropology of the writer's mode of presentation, shaping in advance how figurative visual language is thought of and written about. According to the fourfold categorization of tropes set up in the sixteenth century for the classification of rhetorical effects and reactivated recently for nonscientific discourse and varieties of historical writing, the available modalities here consist of the ironic, the metaphorical, the metonymic, and the synecdochic.[48]

The ironic modality represents a quality of self-affirming artifice that appears in the tone of the whole, amounting to or implying a critique of the viability of any other kinds of language use for the characterization of its subject. Metaphor consists, in its more extended form beyond the individual phrase or sentence, of a play with the possibilities of analogy and of alliance among differing conceptual frameworks, to create a structure of relations that can be deployed for cognitive as well as evocative purposes. Metonymy, which designates in its grammatical form the naming of a part or attribute in place of the whole, or of an instrument of cause in place of its effect, contrasts linguistically with metaphor in the combinatory juxtapositions and displacements of context that it introduces on a larger scale; while synecdoche, which is often confused with metonymy or taken as a subdivision of it, singles out some aspect of the larger entity that is in question with a particular strategy of emphasis on its representativeness for the purpose of expressively characterizing the whole.[49]

Gombrich, who does not mention or use the term *classicism* in *Art and Illusion* and who calls Poussin "the great traditionalist" there (174), is ironic in his modality of presentation because he effectively undercuts the interpretative claims of others by seeming to have access to a direct perception of the relation of creative processes to the world of experience and its realities and because of his self-consciousness regarding the limits of interpretation. In the self-evident selectivity of the examples that he uses as illustrations, he claims only that the point that he is making applies in that particular case, not that it has any overall application to the artist in question or to his oeuvre. Steinberg represents the metaphorical in the very choice of his section headings, allying his language with what he is claiming or suggesting in a linked series of divagations, each of which gives embodiment to a particular structure of figurative relationships that he is concerned with identifying: the signal at the breast, potency under check, the body as hierarchy, the blood-hyphen, the protection motif. Clark's modality is metonymic in the characteristic fashion in which he assembles social and behavioral details in order to link the way in which the suburban and exurban countryside is perceived and used during the period of outdoor impressionism with the painters' perception of it, by a substitution of the part for the whole. To give just a single example from the chapter on that topic, the "floating, tilted, improbable woman's hat" in Manet's *Boating at Argenteuil* is singled out as the "strongest sign [of]

flatness in the picture," of that "found flatness" which Manet literally "saw around him in the world he knew" (164).

Blunt's *Nicolas Poussin* represents the fourth and final possibility. It is cast presentationally in the modality of synecdoche, that is, where the context is one of persuasion, a procedure that entails the exhibition of a selected feature of the whole in such a way that this feature throws to the fore those characteristics of the whole that the writer or speaker desires particularly to emphasize. Just as the figurative statement that a person is "all heart" expresses a perceived aspect of character that the speaker has come to regard as essential and wishes to emphasize accordingly, so Blunt maintains in effect that "Poussin is all learning" not just in discourse or in knowledge of ancient writings (as his early biographers recorded) but in the paintings themselves. This claim puts a construction on the art as a whole, endowing it with a certain essence that, once assumed, can then be amplified and extended to explicate other features.

The four modalities of art history that have been brought together here represent, in their differing tropologies, differing ideas of truth. Blunt wanted his art history to bear the stamp of rationality and logicality that first drew him to Poussin. In the cumulative practice of weighing evidence and assessing rival possibilities, he moved beyond contextualization to the conclusion that Poussin's orientation and affiliations, as artist and thinker, set him philosophically alongside Corneille and Racine.[50] Distinct in character from all his other writings, Blunt's *Nicolas Poussin* is an example of a book that is successful because of a mirroring relationship between the character of the argument and the personality making the interpretation. Its presentation marks out figuratively the aims, ideals, and general shape of his own career. Hence the authority that accrued to it on its appearance.

As to the ultimate convincingness of this account of Poussin, Blunt was a specialist in French art and in the seventeenth century. This motivated him, while showing familiarity with the culture as a whole, to concentrate on a particular unit or part of it in order to evaluate its manifestations in depth and in detail. Generally speaking, the findings of specialists are or become disputable when they betray in some obvious sense how they were arrived at. Unlike Roger Fry's, Blunt's way of evaluating disguises the personal factors at work in what he was doing. In writing about Poussin, Fry recapitulated and distilled the effect that the

paintings had had—directly and via those of Cézanne—on his own way of thinking about art, and his own painting also. Blunt is convincing, by comparison, in an artificial way that colors his entire argument. He masks over, rather than exposes in a self-aware fashion, the tropology of his rhetoric.[51]

Chapter Two

The Study of Imagery and
Creative Processes

ENCOUNTERING FOR THE first time Piero di Cosimo's painting now in the Wadsworth Atheneum in Hartford and its pair in the National Gallery of Canada in Ottawa, we are likely to be puzzled as well as intrigued. Without the titles, *The Finding of Vulcan* and *Vulcan and Aeolus as Teachers of Mankind,* it is hard in the first place to identify the imagery in these paintings, that is, the subject matter together with the way that that subject matter is presented. Even with the titles, however, there is the question of why an Italian Renaissance artist should have chosen to depict this particular mythological story, and the specific incidents in question. Piero di Cosimo's career as a practicing painter based in Florence stretches from the end of the fifteenth into the early sixteenth century, but there is a seeming lack of parallels or connections between his works such as these two and works of other painters active contemporaneously in that same environment. This is commonly, and understandably, explained by reference to Vasari's Life in which the extraordinary eccentricities of Piero's personality and behavior receive particular attention, and form indeed, with their supporting stories, an explanatory focus framing the account of the artistic achievement.[1]

One of the great triumphs of the iconographic method is Erwin Panofsky's exposition, first published in 1937, of how a specific textual source—in fact a linked series of classical texts and the interpretation that they promulgated of the early history of mankind—lies behind these

paintings.[2] In his expanded version of this interpretation (1939) Panofsky began by identifying Piero as "not a great painter but a most charming and interesting one" whose roots in the Florentine tradition are to be explained by his apprenticeship to Cosimo Rosselli, whom he aided in the decoration of the Sistine Chapel with a contribution to one specific fresco (the *Sermon on the Mount* of 1482, for which Vasari states that he did the landscape) and by the influence of Signorelli. Nevertheless he "stands very much alone" in that tradition by virtue of an imaginative and inventive rendering of light and atmosphere, plants and animals that gives a "definitely Northern flavor" to his creations. Panofsky went on to identify the source of inspiration for the Hartford painting as a variant version of a passage in Servius's *Commentary on Virgil* in which Vulcan was misstated to have been brought up on the island of Lemnos by nymphs. The Ottawa picture for its part was based correspondingly on a section of Vitruvius's treatise on architecture (drawn upon by Boccaccio in his text on the genealogy of the Gods, in order to expand on a doctrine emanating from Lucretius's view of the early development of humanity) describing the construction of a primitive frame house on exactly the lines shown to the rear of this picture, while Aeolus, the God of the Winds, as narrated by Virgil, is shown befriending Vulcan by using leather bags as bellows to heat up a fire for the forge in Vulcan's workshop. Panofsky ended by returning to Vasari's authority in using Piero's "bestial" and neurotically ordered life as a warning example of the effects of derangement, and to one particular phrase there that "furnishes a key to the nature of the man": "he enjoyed seeing everything in an undomesticated state, according to his own nature." For the art historian, this corresponded to the way in which Piero's creations, like the two paintings under discussion and others from his decorative cycles which are related in theme, gave off

> a pervasive atmosphere of strangeness, because they succeed in conjuring up an age older than Christianity . . . than civilisation itself. Piero di Cosimo might be called [in this light] an atavistic phenomenon. . . . In his pictures we are faced . . . with the subconscious recollection of a primitive who happened to live in a period of sophisticated civilisation.[3]

In his later work from about 1505 to 1515, however—a decade or so later than the Hartford and Ottawa canvases—Piero, while still preserving an archaic flavor based on his looking back to the artistic examples

6. Piero di Cosimo, *The Finding of Vulcan on Lemnos*, c. 1490. Wadsworth Atheneum, Hartford. The Ella Gallup Sumner and Mary Catlin Sumner Collection.

7. Piero di Cosimo, *Vulcan and Aeolus as Teachers of Mankind*, c. 1490. National Gallery of Canada, Ottawa.

that had first affected him in the 1490s (Hugo van der Goes, Filippino Lippi), also moved forward to take in, if only spasmodically and in chronologically separated works or groups of works, the example of Leonardo da Vinci and of the High Renaissance generation that included Fra Bartolommeo, Andrea del Sarto, and Franciabigio.[4] That this took place does not necessarily affect the picture of his isolation and dislocation, but it lessens the degree to which eccentricity can be held responsible for choices of imagery and presentation. As Sydney Freedberg put it (1961), after the reseeing of the later work had begun to affect what was said about this artist, "the meaning [of his vocabulary] in its essence was not without an audience ready to understand it . . . amongst the younger generation . . . and so [came to make] a living link between what preceded and succeeded it."[5]

The initial problem here, then, is how far—for all the fascination of the connection between extant art and reported life—it can be assumed that the whole personality of the artist is contained, expressed, or distilled in each and every image of his. This is a problem that directly links the invention and making of pictures with the activity of dreaming, of which more will be said subsequently.[6]

A second problem that emerges in the case of eccentric artists is how the private and the public aspects of their work can be interlinked for interpretative purposes. *Public* aspects of the work are ones that, in the character of the images themselves and the way they are structured and presented, are posited as being accessible to "unprivileged" viewers who possess and bring to the work nothing more than a built-in receptivity. *Private* aspects, correspondingly, are those that a privileged viewer may be in a position to discern: one, that is, who has an avenue of access to the work's meaning not normally available to others, or not available without special bases for familiarity or sources of insight.[7]

The interpretation of private imagery thus tends to mean that the artist is accorded the role of supplying information on the basis of which the work is to be understood; or failing that, someone directly privy to the artist's thought and state of mind is given this role. The interpretation of the work as product of a public form of activity treats it, contrastingly, as having a capability of outreach of a more general sort, and may accord the affording of insight into its character to anyone in principle, outside of a closed circle of hermeneutic authority leading back to the artist. Works of

art engendered by wholly personal circumstances within a given social context may, in the character of their imagery, pose the issue of interface between the private and the public, and do so for interpretative purposes in seemingly declarative form. Hugo van der Goes, whose Portinari altarpiece Piero di Cosimo evidently drew on while it was housed in Florence, provides a good example here. According to report Van der Goes actually went insane during his last years, before his death in 1482; but he also recovered enough to be able to paint toward the end, producing according to the consensus of scholarship today at least three major works within that time period: a *Nativity* (now in Berlin), the *Death of the Virgin* (Bruges), and panels of the *Trinity with Donors* (now in Edinburgh).

The contemporary account on which our knowledge of Van der Goes's psychotic episode rests, and the sole source for our comprehension of the nature of his madness and its possible relation to the character of his late work, was published, in French translation, only in 1863. Forming part of the *Chronicle of the History of the Red Cloister*, a monastery in the forest of Soignies outside Brussels that was affiliated with a later medieval reform movement, the Windesheim Congregation, it is the work of one Caspar Ofhuys, a brother from 1475 who (since he says nothing specific about Hugo's artistic activity or his creations) was evidently simply registering the beliefs of the congregation, in what appears as a somewhat sanctimonious and even self-righteous fashion.[8] According to this account, while returning from Cologne with a group of monks belonging to the congregation—probably in 1481–82—Hugo tried to kill himself and "uttered unceasing laments about being doomed and sentenced to eternal damnation." The attack was so severe that Hugo had to be forcibly restrained. When the group reached Brussels he was ordered by the prior to be given therapy in the form of music and "other soothing performances" arranged for him. But he continued, back at the monastery, to suffer the same pattern of depression, despite everything that the brethren did to try to help him.[9]

Writing some three decades after the event, following which he had become *infirmarius* of the monastery, Ofhuys is extremely specific as to Hugo's symptoms, the diagnosis to be made, how the affliction was treated, and its possible alternative causes. But apart from expressing his evident aggrievance that Hugo had been allowed to go on painting, after leaving organized professional life to join the order, and given special

8. Hugo van der Goes, *Death of the Virgin*,
c. 1481–82. Musée Communal, Bruges.
Copyright A.C.L.-Brussels.

privileges, he makes no case for there being any direct or evident connection between his religious disposition and his pictorial practice, except to say that Hugo was deeply concerned in his illness as to how "he could ever finish the works of art he wanted to paint." The result is a dual tradition of interpretation in modern times: on the one hand personal, on the other, social. One side stresses the quality of personal conflict or torment seen as emergent in the late paintings, the other the conditions under which Hugo practiced his art before and after he joined the order, for which he created the *Death of the Virgin,* and the requirements of humility and mortification of the senses imposed by the order under the impact of its most famous member, Thomas à Kempis, whose *Imitation of Christ* was probably composed in 1441 and began to appear in translation at midcentury.[10] A recent revisionist viewpoint here puts its emphasis on how ideals of the Modern Devotion practiced by the congregation gave Hugo occasion to structure his sensibility or personal vision accordingly, suppressing depth in the late paintings, emphasizing the revelatory role or meaning of light and concentrating on gestures and expressions as ways of communicating inner feeling directly.[11] The important thing, finally, is not to privilege individuality over the conditions of artistic production, but rather to bring out the spiritual component or aspects of the works, especially what is basically their nondiscursive character, since they appear "all at once," as in a dream, and the order of their description is correspondingly a matter of indifference, as it is to the dreamer.

Supposing that the artist is—as far as is known—a person of relative normality, but one who also had a spiritual disposition, like Jacopo da Pontormo; then one finds in fact the same basic alternatives of the "private" and "public" emerging in interpretation, with the same difficulty in bridging the two. In his character sketch of Jacopo at the close of his Life, Vasari notes his frugality and his marked fear of death, as well as his innate good breeding, but he gives his career a perfectly orthodox trajectory in terms of apprenticeship, patronage, and achievements. The only point where a different note breaks into the Life is in the account of how, during the plague of 1522 that ravaged Florence, Jacopo took refuge from it in the monastery of the Certosa di Val d'Ema, three miles outside the city. While frescoing the cloister there with scenes of the Passion, with the aid of Bronzino alone, he took advantage of that "quiet, silence and solitude, which so suited his genius and nature" to study and show the

world that he could vary his style in animation and power of expression. This he did by using as source material Dürer's series of engravings of the Passion, which had recently reached Florence and which the monks approved of. Vasari did not care for the "German style" that resulted, but he saw it as significant that Pontormo spent several years on the task (1523–25), and after the plague was over and he had returned to Florence, continued to frequent the place and did further works for the friars, including a *Supper at Emmaus* for the guestroom.[12]

Modern interpreters have frequently linked Pontormo's religious art to the influence of the Protestant Reformation, or alternatively that of Evangelists within the Roman Catholic Church.[13] But it has been left to a recent commentator to connect the retreat that the plague provided with exposure to the Carthusian faith and its practice of spiritual contemplation, with results akin to those attributed to Hugo.[14] Again, the basic task is to uncover a "logic"—possibly a subconscious one—underlying what Pontormo did here, and thereby bring to consideration a motivation for his use of the Dürer prints in that particular way, and his inclusion of himself in the *Way to Calvary* as a major participant, assisting the fallen Christ to lift His Cross. To determine his sources of inspiration, including visual ones other than the Dürer series alone, and the transformation that he worked on them is to recover at the same time the role of imagination in his creative processes.[15] And this is to be done by bringing to the fore and illuminating how recollection and reconstitution took place, within an assisting context.[16]

It is here that the analogy with the interpretation of dreams asks to be taken up more fully. Already in the ancient world such interpretation was regarded both as giving access to the workings of creative imagination and as a form of social communication. A full-scale study of the subject and of the legacy of this tradition of thought through the ages in Europe is, however, conspicuous by its absence.[17]

One reason for this absence is that the source material for the study of the constructions put on the activity of dreaming consists primarily of narratives of dreams, which are often of a highly artificial or literary kind. The interpretation is then a built-in part of the way the dream is presented. The situation created in this way is akin to the one that art historians

9. Jacopo da Pontormo, *Supper at Emmaus,*
1525. Uffizi, Florence. Photo Alinari,
Florence.

confront when elaborate descriptions of ancient works of art substitute for their actual survival and are the only sources of knowledge as to their character. What happens then is that a knowledge of the terms in which the works were discussed, according to models of discourse about art that were in force while they survived, replaces knowledge of the visual terms within which the image operated. One is told what was shown, and one may apprise the basic function of the work, but the nature of the imagery and the accidence of its presentation lie beyond recovery.

It was to fill in comparably what was missing, for explanatory purposes in the case of dreams, that Sigmund Freud developed his interpretative theory at the turn of the nineteenth century. That Freud was interested in ancient works of art, which he collected, and also in Renaissance masterpieces tied to biographical narratives of personality (beginning with childhood) makes the comparison doubly interesting. One side to explanation lay, for Freud, in the development of a causal theory of a natural-scientific kind modeled implicitly on the ideals that had shaped his early medical training. Dreams, according to the view that Freud propagated here, are hallucinatory forms of wish fulfilment constructed by the same kinds of psychological mechanism as the symptoms of neurosis; repression leads to their expression in disguised and distorted form. A second mode of explanation for Freud was to focus on the mental processes or devices he called "condensation" and "displacement," and to suppose that these mental processes lead to forms of presentation in the dream world, whereby people and relationships are represented or given imaginative embodiment in the same sort of way as in figures of speech, that is, according to the principles of association between one person or thing and another. A substantial section on the workings of symbolism was in fact added by Freud to his theory of dreaming, in its published form, only in 1914. In additions of 1925, Freud make acknowledgment of the debt that he owed in that connection to Wilhelm Stekel's *The Language of Dreams* (1911), but in qualified fashion; he had learned gradually to appreciate the significance of the "unsuspected translations" put forward there, but he also made it clear that the intuitive way in which Stekel's interpretations were arrived at was to be distrusted.[18]

In between those dates Freud published two particular and famous studies of individual works of art from the High Renaissance: Leonardo's *Virgin and Saint Anne*, which he associated with a "memory of his child-

hood" (1910), and Michelangelo's *Moses,* which he saw as representing the moment in which Moses' response to the faithlessness of his people shifts from wrath to recovery. In the first of these studies Freud took up a conceptual construct that he found present in the painting—namely the dreamlike fusion of the "two mothers into a single form." He interpreted it as referring to, and bodying forth, a latent condition to which Leonardo was subject, in the same basic way as dreams and symptoms refer to and may represent conceptions that are at work in the mind of the patient. In the Michelangelo essay, citing in support of his approach Giovanni Morelli's demonstration that, when it came to determining authorship, the most telling signs of artistic personality lay in the most seemingly insignificant pictorial details, he focused on specific morphological features such as the pointing finger and the position and shape of the tablets. He took these features of the presentation to be signs directly indicating Moses' condition of mind and feeling, and the presence of a process of change at work within him, in the same way as inflections or tones of speech in the use of language serve as indicators of the speaker's state.[19] In this way Freud affirmed a distinction between the workings of symbols and of signs that (depending on the modality of expression or communication and the way in which the input is received) is not in fact that absolute; and he defined the field of symbolic interpretation as one entailing the assignment of a determinative role to unconscious impulses and motivations, rather than as a field in which relationships back and forth between the "private" connotation and "public" or commonly accepted signification may be found and explored.[20]

Recent psychoanalytic theory, in contrast, takes interpreting to mean that one participates, as therapist, in the imaginative world of the analysand, seeking to match words to that world and to abstract from it some cogent sense of the complex relationship of facts and values to one another. It means holding back and denying foreclosure, in a transitional fashion, until a "sense" or meaning reveals itself. It also means that particular importance is given to the context and framework that the therapist offers for and during the analysis, including rapport with the patient and the ability to notice and single out particular thematic emphases or juxtapositions within the materials put forward.[21] To interpret a particular dream entails, accordingly, investigating the processes of mind and experience that underlay its coming into being, as for example the

patterns of its occurrence and whatever forms their background. It also entails concerning oneself with how the experience and its recall are received and apprehended on the patient's part: with the feelings and responses that they instill. The analyst, rather than attaching a fixed symbolism to the dream's components on the Freudian model, thus presents the dream as a whole as the product of an active and imaginative transformation, in a way that makes sense to the analysand.

Dream interpretations, understood this way, come to seem analogous to the interpretation of pictures, in the double sense that the therapist, making himself or herself familiar with the modes of imagining of the patient and the forms in which these modes express themselves, must translate from one language, the visual, into another, the verbal; and that he or she uses this knowledge of "the grammar and syntax of such translations . . . to interpret [the dream] back again into the communal language of consciousness," according to a semantic, rather than a causal, theory of explanation.[22] There are still the obvious objections to the analogy that dreams include other than visual elements to their composition, especially the sense of words spoken; that they are both spatially and temporally unlimited in principle and carry a sense of duration to their occurrence; and that they are known of or known about as imagined experiences only through the recollection and subsequent description of their character on the part of the dreamer. To which it can be answered that, true as those points may be, it is also the case that pictures frequently include words in the form of texts within or alongside them, or give the impression of words spoken in the way that patterns of expression and gesture are apprehended. Internal arrangement may be used to give a sense of sequencing in time, and varying devices can be brought into play to break the sense of a coherent space or a single unified moment in time. Most importantly, the act of describing and discussing the character of dreams is one that puts a frame around them, like that given to pictures when singled-out episodes or conjunctions of image are disposed within a containing arrangement that imparts to the viewer a sense of focus and of structured apperception.

In fact, the analogy drawn up on these terms between dreams and pictures is one that recovers a longstanding tradition in European thought, and this may be the strongest point about it. Already in the mid-thirteenth century Albertus Magnus, dealing with divination from dreams, wrote that

"The interpreter must be quick to see associations and similarities from the realm of . . . art" as well as of nature.[23] In Shakespeare's plays, the view found early in *Romeo and Juliet* and summarized in the plot of *The Tempest* that dreams are to be associated with a visionary transformation of the world into artistic form is made explicit in *A Midsummer Night's Dream* in the episode of "Bottom's Dream," which is acted out like a tableau, and Bottom's own subsequent comment on it (act 4, sc. 1).[24] And the specific vehicles of such transformation are named in Philip Goodwin's *The Mystery of Dreams* (1658) as "the Fantasy and the Memory, the soul's working shops wherein strange things be wrought; when the soul . . . works within itself, strange things it does which be drawn out in dreams."[25] Correspondingly, schematized forms of communicative practice seem to have prescribed in the Renaissance that the dreamer should be represented alongside the dream experience visualized in a form entailing *condensation* (two or more images fused to create a composite that derives from and partakes of the meaning of both, in a seemingly contradictory fashion); or alternatively that incidences of the grotesque and upsettings of expectation should be fitted into a routine and familiar setting of receding landscape, in a fashion which exemplifies *displacement* (the transfer of characteristic features from one context or sphere of operation to another, so that the context of appearance that would be expected is recalled or allusively referred to). An example of the first kind of practice would be Marcantonio Raimondi's so-called Dream of Raphael print, and of the second Hieronymus Bosch's renderings of the Temptation of Saint Anthony. As in certain tribes and peasant societies, where there is a routine practice of telling dreams as if they were folk stories, it was understood that the play of insight founded on common experience onto the conjunction of images and their visionary urgency offered a path toward reconstituting interpersonally the immediate and charged experience of the dream as a whole.[26]

If interpretation is to serve as a bridge for the workings of art, as in the case of dreams, between private emotional responses and their expression in universalizing terms, then it must not only have the capacity for *translation,* in the sense described, but also be able to show how the context and circumstances of production have contributed generatively. In the case of pictures, it is specific sociocultural conditions that make them an inter-

personal, rather than an intrapersonal, form of communication, through the way in which a mediating response extending itself from patrons, collectors, and supporters of the artist through to a potential public of a larger kind endows them with signification. When the historical context of generation is not known, except in its barest essentials, and the patterns of reception affirming signification are available only in the case of later owners, then it may be conducive to the gaining of a purchase on interpretation to consider access on the artist's part to popular visual traditions, as in the case of Bosch;[27] or to conjecture an awareness of one or more literary texts of a broadly analogous imaginative tenor, as in the case of the Raimondi "Dream."[28] Such formulations are broad enough in their purview that a specific linkage in the form of cause and effect need not be in question. But once this kind of a suggestion as to sources has been made, its possibilities for further elucidation by art historical means seem to draw to a close.

Where the issue of context is less elusive, in the sense that historical details can be brought in and made to apply from several different directions, then two alternative approaches to the recovery of signification open themselves up that are not incompatible with one another. It becomes possible to consider the artist as supplying the needs at particular junctures of special interest groups, on the personal basis of friendship or of some kind of ideological association. Or the artist may be seen as participating in the general concerns of the culture, again on a personal basis. Thus it has been suggested recently that Rembrandt's early historical paintings were not made for stock, as traditionally supposed, but created on commission for princely and patrician patrons; and that two of their subjects, one identified accordingly as *Palamedes before Agamemnon* and the other, its companion, showing the *Stoning of Saint Stephen* were chosen so as to echo and reflect back onto the programmatic concerns of a sectarian campaign being waged in Amsterdam at that time, that of the Remonstrants.[29] It has also been pointed out that, while Rembrandt was drawn to various unorthodox sects in the course of his life, including the Mennonites and the Waterlanders, his choice of the subject of *Belshazzar's Feast* for a major history painting in 1635 chimes with a favorite concern of the Dutch at this time with providential occurrences that appeared as acts of divine intervention, and with the prophets (in this case Daniel) who foresaw their coming.[30] In both these ways

pictures are taken to "reach" beyond their frames, in the interests they reflect or the forms of contemporary credence with which their dramatic tenor coincides.

Ideally, to recover the processes of condensation and displacement in their historical context—rather than in the more narrowly determinative application that Freud gave to those terms—illuminates the whole picture. The work of imagination and memory upon the materials at the artist's disposal is brought into focus, and so is the transformative power vested in the image to recall and distill a set or sequence of affective experiences. An example of such illumination stemming from a specific discovery is the recent removal of the "conspiracy of silence" that, it can be said in retrospect, had surrounded Goya's large and imposing painting of the *Junta of the Philippines* (housed today in the little museum of Castres) since its first exposure. The assembly shown there gains identification as belonging to a very specific occasion. In April 1815 the painting was commissioned to record the annual general meeting of the Royal Company of the Philippines held on March 30, when Ferdinand VII unexpectedly added his presence and took the presidential chair; and it was created to hang in the meeting hall itself. The man who was responsible for the king's presence and who sat on his left was Miguel de Lardazibal, Minister of the Indies; but rather than occupying that place in the painting he is identified, by comparison to an independent portrait that Goya did of him the same year, as present in the shape of the figure who stands in shadow at the far left, in the embrasure of a doorway. In September 1815 Lardazibal was imprisoned by Ferdinand; "banished by the vicissitudes of the Republic," as the inscription has it on the paper that he holds in the single-figure portrait, he went into exile. His inclusion on the occasion of the assembly, while it was to be suppressed subsequently, must imply a general accord as to its being deserved and may well reflect an agreement on the part of the company's directors to pay him tribute in this fashion.[31] Goya, then, indemnified that sense of tribute and its personal meaning for him by creating a resonant presence at the edge of the picture, as if Lardazibal were in disappearing passage from the scene and already half lost to memory.

When interpretative readings of a picture—as distinct from the application of analytic formulas to it—acquire this kind of critical weight and thrust, they distinguish themselves sharply, in terms of recourse to

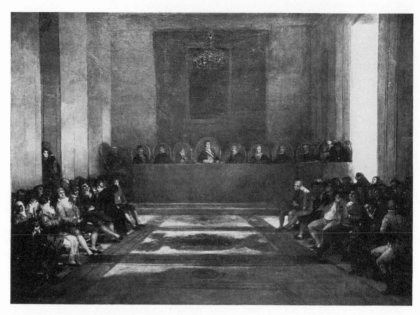

10. Francesco de Goya, *Junta of the
Philippines,* 1815. Musée Goya de Castres.

figurative language and the uses to which it is put, from what may be called *projective* readings. Basically in a projective reading, as in the Jungian technique of dream interpretation known as *amplification*, there is an active and reflexively self-justifying use of association to extrapolate on the character of the imagery, considered vis-à-vis the overall impression that it makes and those features of it that register most strikingly. In the seventeenth century the legitimacy of such a reading of pictures was a function of the merger of fact and value for discursive purposes, as becomes apparent in the words that Federico Borromeo wrote in his *Musaeum* (1635) about a *Winter Landscape* by Jan Brueghel and Johann Rottenhammer, with angels scattering flowers: "[it is] as if the beauty of the flowers and the icy snow were the extremes of nature, as if Earth is represented by the face of Winter and Heaven by the image of Spring" and Borromeo's added comment that "although I see these mysteries and symbols, I did not intend them at all when I ordered the work."[32] The "archetypal" significance of the natural images—to borrow that term also from Jungian theory—provides a meaning here that the viewer's musing elaboration marks out as relevant, even while that viewer disclaims any conscious responsibility for bringing it into being.

In the course of the nineteenth century, however, such "poetic" patterns of interpretation applied to works of art separated themselves increasingly from those that aimed at persuasion. In the writings on art historical subjects of Walter Pater, the very form in which the characterization extends itself from one association to another marks out the idea of the work as a "receptacle" (as Pater termed it) for spiritual and moral "powers or forces" at work. These the viewer is moved toward distinguishing on the basis of "susceptibility to [the] impressions" they make.[33] In a typical passage dealing with Botticelli's Madonnas, and probably based (though it is not named) on a version of the *Virgin and Child with the Youthful Baptist* in a private collection that had just recently been attributed to the artist, the temper of gaze and expression is educed in the words: "[she] is one of those who are neither for Jehovah nor for his enemies; and her choice is on her face. The white light is cast up hard and cheerless from below, as when snow lies upon the ground, and the children look up with surprise at the strange whiteness of the ceiling."[34] In a period when systematic study of subject matter was beginning to find its modern bearings, Pater adheres to the Romantic ideal of an "inner life" to

works of art in the form of a "sentiment," welling its way up and psychically accessible, that asks to be disengaged.

Pater's heir in the twentieth century is, from this point of view, Kenneth Clark. Writing of the imagery used by the major figures of the Neoclassical and Romantic periods, in his book on that subject, Clark comes across as an aristocrat of discernment who can command an understanding of the imaginative processes of others without having to work for the result. In David's *Belisarius asking for Alms* "we find for the first time a feature which is almost like a trade-mark in David's best work: one which undoubtedly had an unconscious symbolism for him, the open palm of the hand." Identified subsequently with action (as in the *Oath of the Horatii*), this motif reappears in the *Death of Socrates* accordingly, "grown extremely small and given to the key figure of Xanthippe, who was originally seated at the foot of the bed."[35]

The following passage of Clark on Ingres's *Mademoiselle Rivière* is in the basic mode of the text quoted from Borromeo, in the way that it slides into figurative language to convey a power of implication vested in the work, beyond its original and straightforward premises as a portrait image:

> she has evoked in [Ingres] a succession of symbols of Spring—the snake, the snowdrop, the tulip and its sheath, the young bird. This straight Spring shoot is lapped round by the folds of a fur boa, which seems to retain some of its animal life. . . . Madame Rivière could never understand what Monsieur Ingres saw in her daughter. A few years after the picture was painted the exquisite sitter died of consumption.

In this kind of interpretative practice fact and conjecture merge into one another, as when Goya's Black Paintings are called "horrible fantasies [that] still [like the imagery of the *Caprichos*] represent the crowd, but many times more monstrous and diabolically possessed," and Clark supposes that, rather than "being frightened of his monsters," Goya "may rather have enjoyed them." The understanding of the workings of the transformative imagination seems here, indeed, to fold in upon itself and create a contextual vacuum around it.

What could the understanding of imagery and creative processes contribute, in a case like Goya's, that is not found in Clark? An answer may be found in the study of this artist by Francis Klingender, a Marxist art

historian whose books have achieved nothing approaching the notoriety and ease of access that Kenneth Clark's have enjoyed.[36] The difference in background between the two could not be wider. Whereas Clark went from the wartime directorship of the National Gallery in London to becoming an internationally known television personality through his programs on art, of which "The Romantic Rebellion" was one, Klingender wrote on Art and the Industrial Revolution and on Goya at a time when Marxist studies had not yet begun to gain a serious place within the discipline (this happened only after the appearance of Frederick Antal's *Florentine Painting and Its Social Background* in 1948 and Arnold Hauser's *Social History of Art* in 1951). The suggestiveness of those writings of Klingender's comes, on the social side, from the multifaceted layering of their author's professional and practical experience—much of it outside of art history; on the personal side, it entails a deep-seated commitment to making sense of the individual artistic psychology in relation to historic events.[37]

Brought by his parents from Germany to England in 1925, when he was fourteen years old, Klingender worked in advertising, taking charge of a market research unit, and took evening classes at the London School of Economics, with sociology as his special subject. Social work in connection with the New Survey of London Life and Labour led to his doctoral thesis of 1934, on clerical labor in London since 1918, which was published as a monograph a year later. He worked on a financial study of the British film industry undertaken for John Grierson; conducted a series of interviews with agricultural experts in regard to the potentials for applied research in that field; and took up the social relations of scientific research as a topic for study, under a fellowship brought to an end by the outbreak of World War II. During the war he was attached to a statistical unit working on a survey that concerned the social effects of bomb damage, and he also wrote a monograph on Russia as Britain's ally since 1812, based on a comparative study of the caricatures inspired in Russia by Napoleon and by Hitler.[38]

Klingender also became in the mid-1930s an active member of the Artists' International Association, a left-wing group, giving lectures for it and publishing an essay on "Content and Form in Art" based on these lectures in its 1935 publication *Five on Revolutionary Art*. This essay is an orthodox statement of advanced Marxist theory at that time, defining art

as "the most spontaneous form of social consciousness" and its content as "an expression of the peculiar emotional and intellectual response of the given social group to the material conditions of its existence . . . form [being] the language by which content is communicated." Historical analysis becomes accordingly the attempt to "interpret each of the innumerable manifestations and theories of art in terms of the specific social group whose art and artistic conceptions they were."[39] By the beginning of the war Klingender's sense of the materials available for such a study widened to include the traditions of caricature and of popular art more generally. This bore fruit when, as director of the Charlotte Street Centre of the A.I.A. in 1943–44, he mounted exhibitions on Hogarth and English Caricature and "John Bull's Home Guard," the former providing materials for a picture book with the same title.[40] He also, during the Spanish Civil War, had begun research on Goya and he published an article on the *Caprichos* as a structured series at the beginning of 1938, dealing with issues of realism and fantasy, followed by the book completed in manuscript in 1940, though not published till 1948.[41]

Klingender's sympathy for the lower classes, based on his sociological experience, emerges in the long introductory section of that book, which details the sociological conditions of eighteenth-century Spain. Particular importance is given there to the democratic heritage that across several centuries assured that "heroes of the working class" should become "the representative and envied models of Spanish society." It also assured that a tradition of "popular realism" in both literature and art should not be forgotten, even when it had ceased to flourish after its culmination in the seventeenth century, and so become available to Goya in the 1790s. It is on this antecedent basis that Goya's production of etchings and paintings during the war with the French comes to be characterized in parallel to the realistic productions of the revolutionary theater at the same period: both "expressed the outlook of a vanguard fighting for social, no less than national freedom." Klingender's exposure to the British tradition of radical social protest in the form of caricature also gave rise to the idea that Goya's familiarity with types of imagery established in that tradition led him to use animals and monsters comparably for his purposes.[42]

Responding to the outbreak of war as a naturalized German living in England, Klingender was also inevitably struck by a sense of strong analogy between the events he had lived through and those that had

shaped Goya's cycle of the *Caprichos,* rendering commentary "really superfluous"; he wrote specifically of a "generation like our own, whose experiences have been so similar," thereby including the Spanish Civil War as basis for the analogy. Later he recalled the evidence of a contemporary that Goya was summoned to Saragossa after the siege there to inspect the ruins and did drawings, as a visiting observer, that were to be destroyed by the French. Though the artist resumed his official duties in Madrid, "the famine of 1811–12 again turned [his] mind to the sufferings of the people" and led to the second main sequence of the *Disasters.*[43]

It is however in certain passages where Klingender can claim to be reading, directly out of the work and its observed details, Goya's transformative processes of creation that his personal touch as an interpreter reaches its boldest heights. Noting Baudelaire's remark that what gives the *Caprichos* the quality of a universal language is "something that resembles those periodic or chronic dreams that regularly besiege our sleep," he goes on to point out how the same observation applies to drawings, like those which relate most directly to Goya's affair with the Duchess of Alba and its outcome:

> The first versions of several Caprichos . . . are contained in a sketchbook Goya used during a visit to Sanlúcar, one of the Andalusian estates of the Duchess. . . . To this estate she retired after her husband's death in June 1796, and Goya accompanied her. Fragments of two separate sketchbooks he used during the visit . . . have survived. They contain idyllic "maja" episodes . . . as well as some intimate subjects. . . . The features of the Alba . . . are unmistakable in several drawings of both groups. . . . But, surprisingly enough, precisely the most intimate drawings reappear, completely transformed and with altered features, as some of the brothel scenes of the Caprichos.

and he then goes on to detail how the Duchess appears in the last part of the series as an apparition with butterfly-wings borne by three witches, and in a suppressed plate, with a double-faced head, caressing Goya while she looks back at a rival lover and has her hand placed in his by her servant; "a castle in the air fills the background . . . a grinning mask [in the foreground] resting on two money-bags appears as a hideous sexual symbol [and] before it a viper hypnotizes a frog."[44]

Again, following an account of the circumstances in which, in 1819,

11. Francesco de Goya, *Agony in the Garden*, 1819. Escuelas Pias de San Anton Abbad, Madrid.

12. Francesco de Goya, *Divine Liberty,* 1820, drawing. Album C 115, Museo del Prado, Madrid.

Goya painted his life-size altarpiece of the *Last Communion of Saint Joseph of Calasanz* for San Anton Abad, the church of the Escuelas Pias in Madrid, and according to tradition added a tiny *Agony in the Garden* as a present to the Fathers, Klingender supplies the following interpretation of one particular drawing and its imagery:

> Less than six months [after delivery of] the altarpiece . . . and his minute gloss on its meaning . . . D. Rafael de Riego and his Asturians again unfurled the banner of revolt (1 January 1820). Their famous march through Southern Spain gave the signal for the overthrow of despotism. On 9 March Ferdinand swore the oath of loyalty to the Constitution of 1812, and on 4 April Goya attended a meeting of the Academy convened for the same purpose. He expressed his exultation in a number of drawings, one of which is a literal translation of the "Christ in the Garden" into a mood of ecstasy. The same broad beam of light traverses the scene. . . . Leaning back to gaze with radiant joy into the light is the same kneeling figure. Halo and gown are replaced by the ordinary hat and greatcoat of the period. On the ground before him are an inkstand with pens and paper, and below is written "Divina Libertad."[45]

The idea of transformation has a double edge here. Goya is shown transforming his own prior imagery, and also as transforming his perceptions and feelings to accommodate the impact of new events on his consciousness. What Klingender does is to establish the links, in the first case, with a specific social context—the idyll shared with the Duchess—and in the second with the succession of political events that followed hard upon one another in the course of 1820. Goya's images, in their final form, and his creative processes are linked together on this basis. Klingender's sense of fit here is imparted not so much by a use of figurative language as by the raising of the whole discussion to a figurative dimension. It is in that dimension, in fact, that the overarching claim that Goya was on the side of the people in their struggle for liberty must be considered and evaluated.

In the works of his last years, after Goya had left Spain for good in 1824 and taken up voluntary residence in Bordeaux, Klingender sees a "heroic recovery of his social outlook." The "nightmare visions" created in totally private circumstances in the form of the Black Paintings, "without regard for the art market" and indeed without regard for any audience at all, have now been exorcised. Far from implying any subliminal enjoy-

ment of their monstrosities, such as Clark conjectures—the last series of engravings known as the *Disparates* or *Follies*, with similarly dreamlike qualities of towering scale and nongravitational suspension in a somber and murky expanse of space, are not to be taken equally as "morbid essays in satanism for its sake"—they represent manifestations on a vast scale of Goya's "struggle to preserve his faith in a moment of deep despondency." To this "triumph over the monsters of despair" and the change of attitude toward the world that it engendered, there corresponds in fact, though Klingender does not quote it, the personal and very moving description, by the artist's poet-friend Moratin, of his state of mind and appearance a few days after he crossed the border into exile: "Goya actually arrived, deaf, old, slow-moving and feeble, and not knowing a word of French, and without bringing a servant, needed by nobody more than he, and so happy and eager to see the world."[46]

The final cycle of drawings done in Bordeaux includes studies of idiots, depictions of "benighted old men or women who are counting their beads or praying," and incidents of life observed in the streets and public places such as the circus or fairground. But the majority of the drawings are ones of "ordinary folk at work in their houses or tending their children; men working or having a drink; children, courting couples and old people." Such "documentary realism" serves to express Goya's "reassured confidence in the people." Klingender reaches here a dimension of discussion where, as in his perception of what motivated Goya's *Divine Liberty* and the spirit with which it is informed, the "private" and the "public" are effectively fused.[47]

Chapter Three

Indeterminacy and the Institutions of Art History

STANDING IN FRONT of Jan van Eyck's *Arnolfini Portrait* in the National Gallery in London, or discussing it with colleagues who specialize in this period, I recognize that we do not know, and never can hope to know beyond reasonable doubt, what exactly the picture shows; and that this should be so is part and parcel of the picture's perennial fascination. Explanation of works of art rarely achieves what appears as a perfect convincingness; and if it does do so, it is only for a limited time that facts internal to the work—the specific people and things depicted, and in this instance the artist's signature and date joined to that depiction, as an integral part of it—seem to correspond to external evidence that is brought to bear. This, then, is the measure of an irresolvable indeterminacy that attaches to the work's character. On the other hand, ongoing discussion of the work and what it shows assures also the continuance of the picture as an object of intrinsic interest, to audiences of different kinds.

The particular example of the *Arnolfini Portrait*[1] is one that brings up both the character and the history of the art object, and also the role of appended commentary, in showing the way that a particular "representation" of the object was arrived at. The forms of representation that are available for an image such as this have included in the past reproductive processes (like those used to generate line engravings), and today they include various kinds of visual replication (like those that are employed to produce slides or rescaled color plates); but here we shall consider only

13. Jan van Eyck, *Arnolfini Portrait*, 1434.
National Gallery, London. Reproduced by
courtesy of the Trustees.

"representations" in words, which take a form that is in key respects analogous to anthropological or sociological reports from the field. They are attempts at a "synthesis" in which, once a certain description of the work has been put forward and accepted, its details are then revised and extended in the light of new data and assumptions.[2]

Thus the earliest references to the picture that are known, in the inventories of the collection of Margaret of Austria in the early sixteenth century, give the name of the man portrayed in varying forms (Hernoult le Sin, or Fin; Arnoult Fin) but not that of his wife, whose presence in the same room, touching hands with him is noted; they give the name of the painter (Johannes) and that of the previous owner, Don Diego da Guevara, whose arms were emblazoned on the exterior wings (long since lost) that served to protect the image. The inventory of Mary of Hungary, from the mid-sixteenth century, adds the date of 1434 and the presence of the mirror in which the man and woman are shown reflected. The first accounts of the painting included in historical texts, those of Marcus van Vaernewijck (1568 and 1574) and of Carel van Mander (1604) now specify the work as being Jan van Eyck's and add that the couple who pledge themselves are being "married by Faith": a detail hard to interpret—since though a dog may symbolize Fidelity, no one has ever supposed that the little griffin terrier that appears in the foreground is officiating in some kind of a personifying fashion—and therefore presumably based on a misunderstanding. In the Spanish Royal Inventory of 1700 an inscription from Ovid on the frame of the picture (again, now lost) is mentioned, and later Spanish inventories add that the work is in oil, while the first British listing, of 1812, records its exact dimensions. So far, then, the descriptions that we have treat the work as both archive and precious object; they identify it as both the record of an event, and as an example of a famous artist's creativity.

Once a work has entered a public collection, on the other hand, as this one did in 1842, the role of commentary in relation to it alters. To render the object more accessible in character (rather than simply assisting its survival by identifying it as special) becomes a way of smoothing the transition to national ownership and public perusal. For John Ruskin in 1853 the signature "John van Eyck was here"—so it should properly be translated—"is characteristic of the spirit in which the painter worked: he only professed to come, look and record what he saw"; so that the

attitude toward experience underlying both this work and the portrait in the National Gallery inscribed with the artist's motto in Flemish, "Als ich kan," is to be taken as one and the same.[3] Knowledge about the picture in the form of early references to it is subsequently systematized, and the time then becomes ripe to reinvent a context that will explain its character. Such was the contribution of Panofsky's classic article of 1934 on the picture, claiming that a marriage was being performed outside the church and that the purpose of the signature and date, along with the presence of witnesses shown reflected in the mirror to the rear, was to make the painting into a document of the occasion.[4] The great authority that accrued to this account comes from its marking out a new synthesis, applicable not just to this painting as an ad hoc explanation of its character, and not only to van Eyck's work like Ruskin's suggested reading of it, but also to Flemish painting of the fifteenth century more generally. In Panofsky's words, explaining the notion of "disguised" significance, "attributes and symbols are chosen and placed in such a way that what is possibly meant to express an allegorical meaning at the same time perfectly 'fits' into a landscape or an interior apparently taken from life."[5]

The raised right hand of Arnolfini has, however, returned like a troubled spirit to haunt the afterlife of Panofsky's argument. For Bedaux (1986) the scene represents a particular marriage being contracted, and the "customs and gifts which played a part in it," rather than the actual ceremony.[6] Bedaux offers a reading of the attributes and objects included that is basically akin to Panofsky's, except that the interpenetration of the material and the spiritual that, for Panofsky, was to be ascribed to the fact that objects naturalistically depicted are at the same time endowed with a symbolic significance is, on Bedaux's understanding of the picture, based on a reversed premise: all the objects that are literally presented within the environment have, traditionally, symbolic reasons attaching to them for being included in such a context. For Harbison, both of Panofsky's basic tenets about the work—that it had a documentary function, and that there is a consistent symbolism pervading it—become subject to challenge. In van Eyck's capacity as a court artist of the early fifteenth century, and in the context of sexuality, religion, and social standing as these are related to one another in northern Europe at that time, the portrait serves as a commentary on personal, physical, and political aspects of this couple and the way they chose to live their lives.[7] In a richly charged and knowing

intercalation of details, the dog may denote both fertility and carnality; on the chairback behind the couple, a "grinning gargoyle-like figure" is juxtaposed to the two joined hands; and the oranges on the sill, bared foot with slippers and statuette of Saint Margaret may all refer to the expectation that the woman will produce an heir—as Giovanni Arnolfini's wife, Giovanna Cenami, never succeeded in doing.

Granted that each of these latter-day readings of the picture amounts to a reshaping of the primary or visual evidence, let us look more closely at the factors that, in a case of this sort, effectively leave interpretation open. Truth has been defined philosophically as either something to be arrived at "by the best of [one's] lights," or as the establishment of a view of things that relates to "what they are about."[8] Applied to historical studies, the first of these conceptions of truth invites one to consult and use external facts as far as possible; but which ones, and from how far afield? The second calls for the reconstruction of an original function or purpose governing the character of the work, but the requirement of producing a "match" here is extraordinarily elastic in the way that it can be interpreted.[9]

Two different kinds of interpretative procedure come into focus accordingly. Details not obvious in their implications, or hard to interpret in their basic character, may be read in the same kind of general way as one unravels the details of encoded messages. Just as engravings after paintings may sometimes alter the given pattern of a gesture or facial expression, so as to render it more readily assimilable, so words may be used comparably for clarifying or demystifying body language, in pictures as in ordinary life. To observe of Piero della Francesca's *Baptism* that Christ and the Baptist are standing in the water is to present this observation as in effect self-explanatory, given the principle of *imitatio veri* in the fifteenth century. What would have been obvious for viewers of the time, for us requires "decoding": namely, that the story in the New Testament is being followed in this precise respect, and that the logic of descriptive realism puts this observation here in relation to others on Piero della Francesca's work.[10] By the same token, to say in the case of Masaccio's *Madonna and Child* (also in the National Gallery) that the Christ Child grasping at the grapes with his other hand at his mouth is eating those grapes is to transpose this detail, by reading it that way, from the province of the literal into that of figurative import. The implication of the act thereby

becomes proleptic, as a commentary added to the description in this form will bring out. The raised right hand of Arnolfini stands somewhere between those two examples. Basically it may appear as a gesture indicative of the swearing of an oath; but van Eyck altered its position so as to render it less explicit in that respect, and according to Harbison it may recall by association the Angel Gabriel's gesture at the Annunciation, prognosticating an expected childbirth. Likewise, taken literally, the room would appear to be the couple's actual bedroom just as Piero's painted room in his fresco at Rimini carries indications of representing an extension of the building's real architecture; but the space can also be taken, as it can there, as a chamber suggestively prepared for a more sacral kind of purpose.[11]

There is, at the same time, another kind of interpretative procedure that comes into effect when puzzlement is engendered and there is no clear indication as to how the different elements of the visual ensemble fit together. Data, which may consist either of images corresponding in certain of their features to the object under scrutiny, or of texts which can be held to throw light on the character of the object in some pertinent way, are then combined with interpretation of those data to yield speculative suggestions, arrived at inferentially, as to how an adequate representation in words may be achieved. Each such hypothesis entails the rejection of alternative possible inferences, and is in that sense like a claim, whether or not this is avowed. A set of such suggestions in turn yields an interpretative theory—as distinct from the application of an explanatory model not inferentially arrived at but rather (as in the case of larger explanations of a cultural sort) imposing a framework of understanding, like a grid, on selective data that allow this.

It would seem a matter of fact today that an image representing the artist appears in Michelangelo's *Last Judgment,* in the shape of the countenance belonging to the sloughed skin that Saint Bartholomew holds. But the presence of this "skin portrait" was not recognized till 1925[12] so it was as if a way of reading the short hair and curly black beard was come upon then, to go with the fact that the remainder of the skin is being sloughed. If it were a matter of Michelangelo's having whimsically grafted his features onto the saint's mortal skin, in a distorted fashion correspondingly calling for decipherment, then there could be no putting together of skin and face as "another's" to serve as the basis for an

inference about the spirit in which this was done.[13] The visual form taken by the skull in Holbein's *The Ambassadors* (again in the National Gallery, London) must similarly be read not simply as a distortion whimsically introduced at that point in the painting—in which case it would appear arbitrary—but as an anamorphic representation of a familiar type requiring for its viewing the adoption of a totally different point of sight from that entailed in the depiction of the room and its occupants. It then takes its place as having a presumed reason that can be inferred for its being there, just as much as is the case with the inclusion of the terrestrial globe, which is of known date and origin, and of volumes identified by the writing on their pages as a Lutheran devotional hymnbook and a guide to account keeping.[14] The hypotheses that are constructed in these cases have the role of accommodating together the real and the imaginary, the earthly and the spiritual, what is shown forth and what is adumbrated, in a fashion that can be cognitively shared. They represent in that way the creation for discursive purposes of what have been termed "cognizable worlds":[15] imaginative entities that, as laid before one by means of language, are capable of being understood as representative and representational products of a "world," or situational context, that is different from one's own.

In the *Arnolfini Portrait* signature and mirror reflection play out analogous roles interpretatively. Unlike the placement of the artist's name on a discarded shield in Uccello's *Battle of San Romano,* which can be taken as implying an ironic attitude toward combat in this form,[16] here the testimony of the artist's presence at the scene is such that the relation of the representation to the event itself can only be inferred from the nature of the representation. Unlike the image of the artist at work that appears reflected in Saint George's armor in van Eyck's *VanderPaele Madonna* (and which like the Michelangelo "skin portrait" had to await discovery),[17] the figures turbaned in red and blue who are reflected here appear as bystanders in other works of van Eyck's, the *Rolin* and *Vander-Paele Madonnas,* so that they constitute a form of trademark. Like the Vermeer, on the other hand, that used to be known as the *Woman Weighing Pearls* until it was found from microscopic examination that the balance was empty, whatever significance is imputed to the way in which the main action is being performed has to be made relationally compatible with the corresponding presence of religious imagery in the background:

there a Last Judgment in the rear of the room,[18] here medallion scenes of the Passion around the frame of the mirror.

The indeterminacy of the *Arnolfini Portrait* is such that it is impossible to draw a line between internal and external data for interpretative purposes. The inscription from Ovid that is recorded in 1700 as being on the frame (without being actually quoted) may well have been added as much as a century after the painting was done; but the interpretation we are given of the passage chosen for this purpose—namely, that it "told how the couple deceived each other"—makes it a supplement to the picture in the sense of expressing what had come to be understood as to why the couple are shown, and the relationship of this to their actual history. The words inscribed within the painting supply the artist's name, but the form adopted for the signature, including its elaborated ornamental character, is (as has been seen) open to being interpreted in differing ways that construct a rationale for its role within the picture by reference to some analogical counterpart—motto, document, heraldic flourish—in the world that van Eyck inhabited. Nor is what the couple is doing together, and where, made readily graspable by early descriptions. These, in the specifications they offer, are commensurate either with its being a highly unusual picture for its period that has the marital relations of a particular couple for subject, or with its being a picture with a ceremonial cast to it that, in its departures from expected practice, represents the pictorial counterpart to an act of pledging that actually did take place.

Yet the difference between these possibilities is a modern art historical construct; previously, the relation between internal and external data did not come into question in that way. It is as if, in fact, two different kinds of indeterminacy were at issue. In one sense of the term, which appears here as the older one, the work is always able to receive new and further interpretations. What these interpretations do successively is to undermine the possibility of assigning the *Arnolfini Portrait* to a particular category of production, whether determined by function or by considerations of subject matter. It is a portrait; it is a narrative of action performed in a domestic setting; it includes singular still-life elements—and the kind of labeling that would give the picture a fixed and firm object status is thereby declined or debarred. It might seem, in retrospect, that this happened because the evidence actually available was insufficient as yet for interpretative purposes. But if so, the discovery of that "insuffi-

ciency" was itself a product of the systematization belonging to modern art historical study; paradoxically, it was only after discussion of the *Arnolfini Portrait* had become marked by the quest for an explanatory synthesis that the early inventory records and descriptions were brought together and shown to apply to this painting.[19] So the argument that for four centuries and more the *Arnolfini Portrait,* as if by original design, awaited recognition of the problems of interpretation that it posed threatens to become circular. The early notices, as we have them, shift their focus and to some extent add to one another, but not in response to any such idea of a design to perplex, either on the part of the artist or of the portrait's patrons.[20]

Indeterminacy in the newer sense, in contrast, means that the work lacks a "core identity" as an imaginative construct, and that such an identity needs to be given to it. The threads of adequate description need to be pulled together, as if to enwrap within their grasp for defining purposes a nuclear set of constitutive components. But the question then obtrudes of just how this is to be done. Thus self-consciousness about the problems and limits of interpretation breaks in, and the hermeneutic process turns inward to the processes of art itself, licensing us to ask what would the concept of character mean applied to a work like this, or what view of sexuality does it body forth, and other such questions that cannot be answered for the historical Jan van Eyck but that bring out what seems relevant and suggestive to a modern viewer about the circumstances of the work's generation and reception. The object itself does not change, but the fact that it is seen under certain aspects that are emphasized or singled out lays its character open to ongoing scrutiny and reassessment. Modern cleaning and other tasks of conservation aim basically, it should be added here, not to alter the object but to restore its original character. But the implications of such cleaning for the way that pictures are read is open equally to debate, insofar as its material effects are reflected directly in those aspects of the work that it discloses (as with elements painted over) or (as in the case of colors) brings out.[21]

Understanding indeterminacy in this double historical framework helps to explain the pattern in modern interpretation of singling out different works of the artist each time, to provide points of comparison for those aspects that serve to characterize the work chosen for scrutiny. Just as for Ruskin the portrait now presumed to be of the artist's own features

provided an analogue for the attitude of detached recording that he imputed to van Eyck (and the reflection in the *VanderPaele Madonna* could have been added, if it had not had to await discovery till much later), so for Panofsky the artist's *Lucca Madonna* and *Saint Barbara* provided analogues for the use of "disguised" symbolism, and Panofsky would add soon after a corresponding analysis of the *Friedsam Annunciation*, which is now generally given to a follower of van Eyck.[22] For Julius Held (1957) and a Polish commentator (1974) the painting of a *Lady at Her Bath* that is lost, but known from the record of it that appears in a seventeenth-century gallery picture, provides points of comparison for the sexuality of the theme and the depiction of a domestic setting that includes a reflecting mirror.[23] Held's conviction that that work was unquestionably van Eyck's and dealt also with a theme related to marriage led, along with its similarity of format and proportions, to his supposition that it had originally served as outside cover for the *Arnolfini Portrait*. For Harbison, more recently still, it is in the individual and private portrait commissions that van Eyck was permitted as a court artist that suggestive correspondences are to be sought, as for instance in the lost portrait of Isabella of Portugal known from a seventeenth-century drawing after it, which shows that an explanatory historical inscription was on or added to its frame also. In this way, without constituting proof of a theory, adjunct materials help to build and fill out the kind of "cognizable world" that is being proposed.

The differentiation of earlier and later forms of indeterminacy also helps to explain why Maurice Brockwell's booklet of 1952, *The Pseudo-Arnolfini Portrait, A Case of Mistaken Identity* appears as an anomaly in the ongoing pattern of writings about the *Arnolfini Portrait*. Brockwell supposed that the National Gallery panel is different from the one described in the sixteenth- and seventeenth-century texts cited earlier, and actually shows Jan van Eyck and his wife, while the "rather similar" Arnolfini panel perished in Spain. If made before modern art historical interpretation got under way, such a claim would have merited serious attention. But once that process has commenced, the way that the relation between internal and external data is then posed renders it out of place;[24] as Panofsky put it, it can be thought of only as providing an "extant and recorded painting with an imaginary Döppelganger."[25] This is not only inappropriate to the institution of art history, but also to the pedigree of a

famous image that now belongs not simply to the British nation but to all who come to see it and hear or read about it. The responsibility that this situation has produced has become, as it were, part of the history of the object; and to take serious account of existing interpretations, as they extrapolate on the character of the image, is to confer on Brockwell's claim, by default, the status of being a sport.

There is an intrinsic connection, in fact, between the two historical developments that are being mapped here. The role of interpretative art history, one may say, coincides in its origins with the point where—whatever the form of art may be—the resolution of indeterminacy in the modern sense begins. Dismissal of a claim such as Brockwell's requires only that one explain what, in the way of premises and foundations, interpretations of a latter-day sort entail. One explains, that is, what the modern institution of art history has sanctioned and made possible.

Indeterminacy in the modern sense may arise from the sheer fact that interpretations have multiplied and spawned ever fresh variations. He or she who notes this fact, in order to make a comparative assessment of the interpretations proposed in the past, must then be aware that he or she is adding still another contribution to the overall picture, and that this choice of solution and the response to it will take their place in an ongoing succession.[26] If after the twentieth or even eightieth proposal exhaustion does not occur, this will be first of all because of limitless ingenuity in generating new ideas, especially ones that link the work to external historical facts or data; and second and perhaps more important because each contributor in the series implicitly, if not explicitly, affirms the superiority of his or her interpretation to all the ones preceding it. Thus Raphael scholarship of the last fifty years, while drawing on no new documentary evidence, has been able to use the results of restoration and conservation and cross-connections with the fields of sculpture and architecture, in which Raphael was active, to complicate, revise, and rewrite with a sense of novelty what are essentially lines of inquiry concerning the theological bases and allusions of a work such as the *Transfiguration* that were established before this century opened.[27]

Indeterminacy in the modern sense may also be a matter of not being in a position to resolve in any clearcut way whether a simple or complex

kind of "meaning" is appropriate to the work's interpretation. Those who appeal to the evidence or appearance of an "intention," in order to find a way out of this problem, end up compounding it by the way in which they cut the Gordian knot. Inevitably their "new" interpretations are seen in the light of earlier ones, and so the argument, however causally inflected by the idea of getting back to basics, threatens to become circular. There is no way out or way back beyond the insistency that only one kind of answer can be right. Thus it might seem simple to decide whether Andrea del Sarto's *John the Baptist* in the Worcester Art Museum is wearing a crown of vine leaves or one of ivy in his hair, and technical evidence can be called upon to try and do this. But if the basis for disagreement is a lack of absolute clarity in the presentation of the leaves themselves, then the "simpler" answer of the two is the one that requires no special explanation to support it, and that fact about it becomes the justifying motif—if indeed it is accepted as a justification.[28]

The question of Neoplatonic influence on the art of the High Renaissance goes several stages further, first of all because this influence requires that a connection with specific texts in circulation at the time be affirmed or alternatively be denied; and second because what is not obvious and straightforward in the choice of visual imagery must be dealt with in one of two ways. Either it is assumed to represent an accrual of "hidden" layers of meaning, or the very idea of a sophisticated fashion of the time favoring the compounding of association by reference to classical texts on the subject of Love must be denied as being inappropriate and historically unfounded. Both these points apply particularly in the case of Titian. There is no evidence in the surviving documents that the aristocratic and courtly patrons who competed for his paintings cared, beyond acquiring as fine an example as possible, about what the literary sources for the subject matter might be, or how closely or imperfectly that subject matter might be followed. And among the humanists who enjoyed friendship with Titian and interested themselves in his output, the Neoplatonic texts most widely read and discussed (Bembo's *Asolani*, Castiglione's *Il Cortegiano*) were ones that were pointed anyway in an aesthetic rather than a purely philosophical direction.[29] What Titian said or thought in those two areas of interaction with his contemporaries and his clientele is simply not known;[30] but that very lacuna that left Crowe and Cavalcaselle free to write about light and atmosphere and the enchantments of landscape in

14. Antoine Watteau, *Meeting in a Park,*
c. 1717. Musée du Louvre, Paris. Photo
Musées Nationaux.

15. Antoine Watteau, *Fêtes vénitiennes,*
c. 1718–19. National Gallery of Scotland,
Edinburgh.

the so-called *Sacred and Profane Love* is also reason and temptation for modern scholars to posit a "larger veil of narrative" over the *poesie*, Titian's freshly interpreted mythological subjects done for Philip II four decades later, which is there to be "pull[ed] back."[31]

In seventeenth-century France painted "enigmas" were actually created—works in which the overt subject and overall character of the image were to be taken as the basis for complex interpretative processes of a descriptive and allegorizing kind.[32] The work of Watteau is built, by comparison, around generic types of figure, vague landscape settings, and remote or sublimated qualities of mood. But acknowledgement of that basic point about Watteau's art does not deter the modern art historian from seeking to illuminate why indeterminacy should prevail on those terms, and how its presence is to be accounted for from the point of view of both the readability of the image and the response of a contemporary audience to it, when these works were publicly shown or published in the form of engravings. In the *Meeting in a Park* "men and women try to find the right tunes, the right words, for love," but also—rather than alternatively, because the two kinds of legibility exist side by side with one another—"we are being refused information," by virtue of the figures being for the most part shown with their backs turned, or so that the expressions on their faces remain hidden or impenetrable.[33] In the late and magnificent canvas known as the *Fêtes vénitiennes* (a title that is based on a print after the work and is probably not Watteau's own) the artist's friend and fellow painter Vleughels appears, courting a female partner and wearing oriental costume; Watteau himself may be present, also in fancy dress as a peasant piper, and there are two sculptures showing figures in suggestive poses of a voluptuous and implicitly carnal kind. The work is in principle a conversation piece, of a type inaugurated in the seventeenth century, and it may also have a special meaning based on the portraits that it includes; but whether what is entailed here represents "a kind of risqué, private joke" or the making available in allegorical form of an "image of elite pleasure in early eighteenth-century Paris" can only be speculatively decided, by reference to other works of Watteau or to collateral evidence of public response to the arts at this date. Figures in "theatrical disguise" or "masquerade" rather than in ordinary costume are engaging in a repertoire of gestures and gazes that gain our attention only by virtue of the attention to one another that they imply; and this

remains a source of indeterminacy where iconography must bow out, however precise the meaning found for a particular motif in another context might be.[34]

In the nineteenth century the same sort of problem may occur where the imagery is clearly readable and the detail crisply precise. That, at least, is the way the critic Théophile Gautier took Manet's *Luncheon in the Studio* when he saw it exhibited at the Salon of 1869. "Why," he asked, "the armor on the table? Is it a luncheon which follows or which precedes a duel? We don't know."[35] But there are other works of Manet, like *Nana* of 1877, where figures are cut off as if sliced through; or ones like the *Masked Ball at the Opéra* of 1873, where only the lower parts of a body protrude into the picture space.[36] The problem is then—again echoing the case of Watteau—a double one. Either one must take it that Manet is self-consciously processing materials taken from reality, and that the filtering of those materials through both memory and imagination leads to condensation and excerption rather than to any kind of paraphrase that could be taken as morphologically analogous to the materials themselves. Or the "signs" that Manet makes with the brush must be read as pure "markings"—like the signs of the stroke itself in Chinese painting encoding, let us say, the qualities of "wristiness" or of "inkiness"—and processed accordingly by the cognitive intelligence of the viewer, so that they possess a corresponding authority: that of signs that reinscribe phenomenal or cognitive data in "scriptual" form.

When, faced with a work such as Manet's *Nana,*[37] we devise a story (which might refer to Zola's heroine of the same name) to explain what is going on; or relate the presence of the Japanese wallpaper design with the crane to other examples in Manet's art of the use of Japanese motifs or to the general cultural interest in Japan at this time; or discuss the character of gaze, expression, and pose in terms of related gazes in visual images of an earlier time (especially sexually charged ones), then we are constructing a commentary that serves as a textual appendage to the internal structure (semantically defined) of the image itself. We create in this way texts that are basically exegetic extensions to, or attempted codifications of, what is perceptible in the network of relations making up the painting itself.

Thus interpretations accrue and proliferate that are potentially (if not inherently, like in the Raphael case) competitive with one another. One such line of interpretation has taken the form of saying that Manet was

16. Edouard Manet, *Luncheon in the Studio*,
1868. Neue Pinakothek, Munich.

17. Edouard Manet, *Nana*, 1877. Kunsthalle,
Hamburg.

uninterested in subject matter per se, or increasingly concerned by the end of the 1860s with space and atmosphere, so that he based what he did now on the natural world *as opposed to* the art of the past. Another has proposed that Manet was interested in the appearance and character of his model, here and elsewhere, only in terms of the role that he gave that model to play. The interpretation that is most convincing may be the one that offers a way of making two or more such readings hang together or (as with the special consideration sometimes given to the boy's expression in the *Luncheon*)[38] appear as if they did.

Now the same could already be said, about convincingness of interpretation, in the case of Poussin. But by the mid to later nineteenth century there is the difference—as the intermediate case of Watteau underscores— that the relation between public and private spheres of consciousness is now more fluid. Correspondingly the space for interpretative hypothesis in between, which the art historian tries to fill, is also more open. Thus the critic aware of the indeterminacy problem between art such as Watteau's or Manet's and its audience may choose simply to fill or at least occupy that space with stimulating and engaging discussion. Such discussion need not be directly based on the work itself; but as factuality and documentation become less emphasized, it must in some way reflect or entail an appraisal of the work's character.

In fact, at the very period when the development of institutionalized art history begins to entertain the possibility of a plurality of differing interpretations—systematization having led on to varying methods of contextualizing the work, as described in Chapter One—modern art itself moves to the point, or juncture, of refusing any determinacy of a final or comprehensive sort. It takes responsibility, so to say, for the viewer's not being able to disengage any fixed or clear-cut signification, in a fashion that becomes more explicitly focused than it was in earlier periods.

Among many available alternatives, Matisse's art and its reception may be used to illustrate what this means. As opposed to Cubism, where for all the caprices and whimsicalities involved the component elements of the rendition seem to belong together in a consistent and coherent fashion, a form of free play with imagery and structural configurations is developed in which the clearly identifiable and the seemingly arbitrary are put

18. Henri Matisse, *The Moroccans,* 1916. Oil
on canvas, 71⅜″ × 9′2″. Collection, The
Museum of Modern Art, New York, Gift of
Mr. and Mrs. Samuel A. Marx. Copyright
ARS N.Y./Succession H. Matisse 1988.

into what appears as an acoherent accommodation and a forced tension with one another.[39] As Alfred Barr put it in his book of 1951 on Matisse—the first really substantial monograph devoted to a twentieth-century artist—discussing *The Moroccans* of 1916, now in the Museum of Modern Art in New York, which Barr played a leading role in founding[40] and enriched with numerous works by this artist: "The ambiguities . . . which enrich the composition . . . are ingenious . . . the whole pile of melons with their leaves [yellow and green] has sometimes been interpreted as Moroccans bowing their foreheads to the ground in prayer."[41]

What was the position from which Barr was led to explain the composition with that degree of qualification as to its legibility? Barr was a Presbyterian minister's son who, after training in art history at Princeton and Harvard and a year's travel in Europe, including Russia, became the first director of the newly established Museum of Modern Art in 1929. He remained in charge of the formation of its collections, especially those of early twentieth-century painting and sculpture, for almost four decades. In contrast to the house style of the museum's exhibition catalogues, which he helped to shape in his earlier years there—a style distinctly dandyish in cast and rather precious when it comes to the detailing of interpretation—Barr was an absolute believer from the first in logic of argument and clarity of presentation.[42] He also desired, particularly in the case of Matisse (whom he first showed at the museum in 1931) to cover all available detail as comprehensively as possible. This aim of his extended to the applied arts, to which Matisse had often contributed his talents as both designer and executor, as well as the fine arts. Last, Barr addressed himself from the very first to putting the leading Western democracy on the map—in contrast to Russia and later to Nazi Germany—as far as the showing of modern and contemporary art was concerned.

After inducting the new American public for twentieth-century art by dint of small, select exhibitions and catalogues written by collector-connoisseurs (especially James J. Sweeney and James Thrall Soby) on lines that he inculcated, the problem that Barr faced by the end of World War II was twofold. On the one hand he wanted to preserve a sense of appreciation (as one would for Chinese calligraphy) for and in initiates whose sensibilities he had helped to shape. For this kind of audience what mattered most was an intuitive and sensual response to modern art, without appearance of intellectual preprocessing. At the same time Barr

recognized that the larger public's response to new and creative idioms was not only politically and socially charged in principle but also swayed by national and international pressures. Both those considerations applied quintessentially, among twentieth-century artists, to Matisse; they formed part and parcel of the pattern of his recognition. Barr acknowledged this in the double title of his book, embracing both art and public; in numerous comments scattered through it appreciating the quality of individual works, as well as their achievement; and in passages like the one quoted on the *Moroccans*, with the sense that they give of a seeping through of interpretative responsibility that devolves onto the catalogue writer, as for older works of art when they are no longer hidden in private ownership.

Barr's proselytizing activity at the Museum of Modern Art fits with the modern framework of belief and related behavior patterns according to which museums serve as temples of culture and the works housed within them for scrutiny and veneration are like the relics of saints. "Decorum" of behavior on the part of adherents of the faith, then, consists in showing in participatory fashion one's membership in the larger community to which one belongs: in this case, as a friend of the museum (donor or potential donor) or regular visitor there. In what way does Barr's personal belief and commitment here differ, in fact, from religious faith and its attendant decorum? The answer is that Barr was not just a spokesman for the "modern" in the sphere of cultural consumption, advising private collectors and responding to cultural conditions of the time (as in the case of Russian and German art).[43] He also had the concept of a *structure* within which individual artists fitted. He used that structure as a model for the way in which the modern artist was described as living and working, adapting for this purpose the traditional "story" of the artist in history, applying his imaginative powers to concrete and practical ends, while at the same time "representing" his age.[44]

In the preparation of his monograph on Matisse Barr had trouble with Matisse's memory and reluctance to provide clearcut, detailed information.[45] But he worked by diligent assembly of the available materials and his own sorting through of them to make this a more thorough, complete publication on a modern artist than had previously existed.[46] In fact, it can be said that subsequent discussions of Matisse's art effectively break down what Barr took as integrated, in order to develop a system or

scheme for the cognitive processing of this artist's imagery; they even put a particular cast on Matisse's statements for that purpose.[47] All such "systems" of reading an artist's work are in principle related to one another, and the one that prevails at any given time is the one that counts in assuring the artist's continuing exposure and the growth of his or her reputation. The entry of Matisse into the museum in large quantities entails one such system; exhibitions devoted to a single medium (sculpture, prints, cutouts) or a single period of work (the early Nice years) represent another; and monographs, as already indicated, a third. So the meaning of conformity in the interpretation of a modern artist such as Matisse is then that one accepts a "system" within which interpretation can extend itself; once the system is institutionalized, its results are marked by both feasibility regarding how it informs and replicability regarding what it informs about.

As described, Barr qualified in the case of at least one major painting of Matisse the idea of privileged information, or knowledge[48] that it was his task to arrange and present for both documentary and explanatory purposes. In indicating the fact that the melons could be read as praying figures, Barr gave recognition to a possibility that the larger public would accept (if not told otherwise) or think feasible in its response to the work. But he also made it plain that the "found and representational analogues," as he termed them, were deliberately and consciously set up in order to rhyme both figures (to the right) and still-life elements with architecture. Barr's strategy for the overcoming of indeterminacy in twentieth-century art was thus directed toward two very different interest groups: private collectors and the more general public of museumgoers. Already in his writings of 1929 regarding the new museum, besides naming seven collectors and connoisseurs who had formed a committee in charge of its inauguration, Barr wrote: "Its educational value will be inestimable—to painters looking for encouragement and inspiration, to students of the history of art, to students of contemporary culture, to critics searching for some canon of comparison, to the general public which likes to look at pictures." And again, "the general public itself, which cannot afford to collect, is thoroughly aroused. The rage, untutored as it is, for modernistic furniture is evidence of a new taste."[49]

What lesson is to be drawn from this double allegiance? The art historian is not necessarily caught in a cleft stick here, but he or she must

arrive at some kind of a compromise for the purposes of credibility. Faced with the growing rapidity of passage of modern art from private ownership to public collections—which he helped enormously to engineer in this country, by his writings as well as his person—Barr sought a bridge between the two kinds of indeterminacy described in this chapter. Concentrating on the introduction of order and system into the organization of the available data, and stopping short, quite deliberately, of "interpretation" of a literary or poetic kind, Barr found that bridge in the personality of the artist and the context of creation, as first recorded for posterity by a few practiced devotees, and as channeled through the major institution that he helped found, for this purpose among others.[50]

Conclusion: Revisionist Interpretation and Art History Today

W HAT CAN BE SAID at the close of the conflicts that occur when traditional humanistic methods of interpretation run up against the questions, objections, and counterhypotheses of so-called revisionist art history? Or better, perhaps, what kind of steadying features can prevent what has been called the "end of the history of art": the collapse of the traditional principles of the discipline in upon themselves? Conflicts of the kind that are in question here cannot, once they have surfaced, be made to disappear; and the problem of confronting them at the theoretical level, on the analogy of what has happened in other fields of the humanities, is that elements of theory taken over from those fields must be retailored to fit the particular needs of art history.

The first axiom underlying the argument of the present book is that there is no art historical text without a context provided by the personality of the writer and the circumstances of writing. This means, self-evidently, that the way interpretation is conducted is always the product of a particular perspective adopted by the art historian as to the problems and issues calling for interpretation; and just as the viewer's implied point of sight enters crucially from the Renaissance on into the way that paintings are read, so there devolves from the art historian's viewpoint not just expressions of personal opinion (corresponding to the painter's choice of coloration, or the handling of light and shade) but the very structure and modalities of explanation through which the argument unfolds. Emplot-

ment, tenor, tropology then become ways of separating out, and registering in their persuasive roles, the key components of the rhetoric that the art historian deploys, as described in the first chapter.

A second axiom, on which the middle chapter of the book is founded, is that, granted that the individual object or artifact remains the essential unit of study for the art historian, the role of explanation in this field particularly has to be that of building a bridge between the personal signification on the one hand, and on the other the use of visual imagery as a social and interpersonal means of communication. What can be learned from psychoanalysis on this subject has now entered a post-Freudian stage of understanding, while semantic models of the way in which visual communication operates, of the kind that have been put forward in the fields of sociology and anthropology, supply an antidote to the idea that symbolism consists of the transmission of specific, culturally coded messages to which privileged viewers have the key. The circumstances of generation and reception for individual works of art, rather than being placed to one side as specialized subjects of investigation—bringing to the fore the role of patronage on the one hand, and the critical response accorded to the artist on the other—need correspondingly to be integrated, in a centralized way, into the consideration of how signification takes its force; and the study of imagery and of creative processes proves— at least in situations where appropriate evidence is available—to be adaptable for this purpose.

A third and final axiom, taken up in the chapter on the institutions of art history, is that the giving of value to art historical studies brings with it an accrual of status to the object or objects that form the focus of such study, and has done so ever since the discipline became formalized. Conversely, as works of art enter public collections and a sense of responsibility develops, not just for classifying and labeling them but for making different kinds of audience aware of what it is that marks them out as deserving of special attention, different and often conflicting attempts to mount an interpretative reading that proposes new insights into the character of those works and seeks to render them cogent, become validated as such. The sense of competition among interpretative claims that results from this means that the boundary between facts, whether internal or external to the work, and the putative application of those facts, to support a certain reading of the work's identity, is never totally erased.

This is the measure of the work's ultimate indeterminacy; and even when, as with works nearer to the present in time, recognition of the indeterminacy is built into the line of interpretation adopted, art history still thrives institutionally—in monograph and catalogue form especially—on the proliferation and the potentiality of alternative interpretative proposals.

It follows therefore that, on the first count, art history ought to show self-awareness regarding the prior history of interpretation (as opposed to a merely antiquarian concern with the researches of the past and their results). It should pay attention to the personalities of the art historians themselves, and especially the emphases that they bring to bear in their writings reflecting the formation and growth of those personalities. It should put stress, on the second count, on the qualities of imaginative insight displayed in interpretation and the corresponding uses of language. As opposed to positivistically oriented findings, like those based on the comparison of study with the final work or on the artist's own plays with the possibility of verbal comment attaching to his or her endeavors, genuinely critical arguments about the processes of creativity tend to be ignored within the academy. And on the final count, it should not be assumed that the world of museum people and art history teachers and researchers constitutes an integral community toward which interpretative commentary is beamed. Rather, different answers to the same question are given and different approaches developed, along networks that interlink both alternative methodologies and different interest groups. Some of those methodologies and interest groups are internal to the field, while others (especially today) reach out, in a more open fashion, into fields outside of art history proper, and also into other fields in which visual images are studied.

The process of interpreting works of art combines, in its foundations, a philosophy of history with pragmatic adaptations of purpose to the needs of modern institutions. The philosophy in question has to do broadly with supraindividual forces at work in history, the parts played by outstanding individuals within collective patterns of development that take effect over long time spans, and the aesthetic object as product and residue of the forces and developments in question. The institutional needs that impinge directly on the discipline and its practices are those of the museum; the art market, including dealers, galleries, and auction

houses; the university in its general educational and its specialist roles; and the development of the illustrated book, whether for reference or for the enlightenment of potential readers attracted to the field. The service to two quite different kinds of task—one explanatory of the processes of growth and change, the other expansive of the order of knowledge of particular objects and their creation and reception—means that interpretation, though it will reach plateaus of consensus as to what is both convincing and factually adequate, can never on the one hand displace the presence of an underlying philosophy by mere adherence to "fact" for its own sake. For even though it comes from a variety of sources (notably Vasari, Hegel, and Romantic and post-Romantic theory of the symbol) and those sources have become largely peripheral to the cultural discourse of our time, the philosophy remains present as a "grounding." Nor, on the other hand, can the institutions of art history do more than support or supply ongoing ways of filling gaps, both material and conceptual, in what is taken to be relevant knowledge pertinent to the works themselves.

It follows that there can be no avenue to truth, or ultimate key to meaning, apart from the history of successive interpretations made from particular positions. In parading the fact that this is the case, revisionist interpretation articulates a set of dissatisfactions with what art history traditionally entails, especially the suppressions and ellipses with which it can be charged. It brings with it also a readiness to grapple with the reasons for those omissions, understood in such a way that these reasons can become in themselves a source of enhanced insight. Central issues to be tackled here have emerged as being the roles that sex, gender, and class have played in past interpretation, and the relationship of discourse about art to the exercise of social and political control, by virtue of an "official" or sanctioned reading of the works that is channeled to the public through representative organs of publicity and ratification.

Does revisionist interpretation, conceived of in such ways, challenge the status quo of the discipline to such a degree that no single work, once subject to such an inquiry, can be seen in the same way any longer? Or does it simply supplement the existing and established processes of interpretation? The answer to this is not simple. It is entangled with the standard forms and types of publication in the field, with the degree of access to other disciplines of inquiry that is assumed and with the selection of art objects that is available to form the focus of such interpretative

endeavors. In opposing itself in what it chooses to discuss to the imposed authority of particular "voices," revisionist interpretation may function as a cadre or leading edge in the laying out of new lines of inquiry. But a virtual condition of this is that it should avoid dogmatic rigidity in theory and practice, so that its flexibility and its adaptation of means serve as an expression of the self-awareness referred to earlier. In singling out for consideration issues that entail emergent or long-term patterns in the afterlife of a particular work or body of work, it fractions the field further: the sheer multiplication of case histories and of pieces of evidence that can play a part in their amplification becomes potentially limitless. But the dissolution of boundaries that is entailed here carries benefits that register even within the compass of a narrower specialization. For what has been made plain is that there never was, in fact, a holistic, comprehensive approach to interpretation that devolved from the modern history of the discipline. As in anthropology and sociology, which developed their modern status as disciplines more or less synchronically with art history, what one has is more like a layering of interpretations based partly on projects that read a body of material evidence in a certain way, and partly on the importation of "texts" that are deemed relevant.

The first of these components to the history of interpretation creates a codification of practice, and even of ways of seeing, based on the premise that all the images that include themselves in the purview adopted can be shown to exhibit an underlying communality and coherence as pieces of evidence. The second, in the extremely complex situation that one has of interdependence and mutual responsiveness among different texts that serve as extensions of visual entities or as verbal complements to them, advantages the claims of one kind of text rather than another in such a fashion as to delimit the kinds or varieties of reading that are deemed possible. Further components of the history of interpretation follow from the claims for a "philosophy" of creation suggested by analogy between the so-called "high" arts, and from the assumption that quality is linked to originality in what a major artist does with a theme or motif. Art moves forward, in this view, through its capacity to renew or recreate an existing language in sudden bursts of inspiration that have an autotelic justification.

Revisionist art history seeks to unmask these components of interpretation, to show up their exercise of a determining influence upon

established and accepted forms of discourse, their very language and terms of reference. This means that ongoing dialogue back and forth between the new and the old focuses properly on two things. First there is the degree to which, within the practice of art history more generally (including connoisseurship), a narrowly aesthetic attitude toward interpretation has imposed itself as part and parcel of the methods adopted. And second there is the question of whether art history has tended to hive itself off from cultural studies more generally, by taking for granted that its own principles of interpretation are understood among equals and do not need clear and rational exposition.

There is a need correspondingly for intense debate within art history, which should engage with the idea of an expository method that addresses itself to culture as a whole and with the present possibilities for such a method, as compared to self-enclosing practices that threaten to become dispersive. Art history should also lay out to view the methods that are being adopted for particular purposes, with thoughtful attention to where they come from, exactly how they are appropriate to the material evidence, and the applied fashion in which they are being used. Topics of study suitable for such debate include, among ones that have now begun to be broached, issues of narrative representation in which thematic and structural considerations are combined; the nature of public audiences for art, considered as cultural offering and as spectacle, at particular periods; rhetorical theory and the theory of communication more generally, insofar as it may be transposable from linguistic to visual practices; and the relations of artistic production to the exercise of power, as manifested in the eras of colonialism and imperialism, and the authority thereby given for a generalized interpretative overview of alien cultures and their artifacts.

It is tempting to suppose that art history can reform, or re-form, itself by reaching across to other fields that have taken up art as an essential part of their subject matter or that pay special attention to visual images and treat them as germane to their purposes of argument, fields such as the study of popular culture or of cinema. The same consideration applies, in a different form and with wider historical ramifications, to those methodologies that have developed alternative ways of conceptualizing what has been left aside by the traditional "canons" of interpretation (as in feminist studies); or those that deal in the basic modalities of reading and reception

that make it possible for works of art to serve as communicative vehicles (a branch on the tree of semiotics). But the intensity of ferment and stimulus to rethinking brought about by those developments do not obviate the problem of an "integral" method resting on common groundrules as to what constitutes evidence, and how that evidence is to be judged relevant and deployed, the rules being such that disagreement can occur in a nourishing way.

If reference to those alternative methodologies has been delayed until this Conclusion, it is in order to bring into focus the kinds of "dissent" in which they engage against the background of consensus achieved by traditional interpretative practices. As compared to the inbred assumptions and presuppositions of art history in the past, they are drawing in new audiences through the vitality of their concerns, and indeed actively enlisting them. They are altering the present and future of the discipline so that what appears readily acceptable and natural in the way of interpretation—the subject of the preceding chapters—itself becomes transformed.

The terms on which that transformation is taking place are themselves germane to ongoing debate about the relationship of means and ends within the discipline. For these methodologies bespeak not so much a grafting on and supplying of fresh meanings that can and should be taken to displace the ones accredited previously, as an attempted and fruitful "naturalization" of the inherently divisive conventions and cultural configurations (social, political, race and gender based) that govern interpretation. Making those sources for pluralism of viewpoints available for understanding on a readier, more overt basis feeds back onto how the pictures and other images that are in question are perceived, and this happens and will go on happening whether or not cross-fertilization with other disciplines is entailed.

What is perhaps most encouraging at the present time is the way in which, as part of the expansive climate of thought that is loosely called postmodernist, art history has been led to reflect upon itself philosophically. Such philosophizing allows branches of the humanities at the very least to review where they stand in relation to past practice and its metaphysical underpinnings, to reassess the value of an accrued wisdom about goals of study and methods of attaining them, and to become conscious of the partiality by which particular avenues of study and terms of discourse are accepted as highroads to the attainment of truth. The

present book, by drawing on recent conceptualizations of process, value, and authority in tangentially related fields, is itself a contribution to that process of rethinking, from which new interpretative ventures in a wide range of areas may spring.

My own position, as both an interpreter and a historian of art historical practices, is one of resistance to any cooptive strategy that threatens to separate the content of writing in this field from its distinctive form; or to disempower the individual contribution by refusing to acknowledge the subtleties and contradictions woven into its unfolding, especially as a crafted critique of established lines of interpretation. I find it necessary to engage with theory in an ongoing way, so that intuitive hunches and forms of empathy for the materials considered can be reviewed as clearly as possible, from the standpoint of whether they provide a rationally defensible alternative to traditional ways of reading the works in question. Finally, even though laying claim to a specific method of interpretation may be the key way of carving out an identifiable position within current institutional frameworks and the forms of definition that they favor, I believe that—even at the risk of forfeiting recognition for the position that one takes—one must continue to use actual "doing" supported by concrete argument as well as "saying" in the form of opinion giving to affirm and to replenish those possibilities for the deepening of insight that can prove genuinely liberating for the future.[1]

Supplements

1. Iconography

Iconography is that branch of the history and study of visual images that, according to its classic formulation in this century "concerns itself with the subject-matter or meaning of works of art, as opposed to their form."[1] So understood it implies an approach to art objects, especially those of the Western European tradition, in which specific, intended meanings can be identified to some extent independently of the form, or style, of their expression. Simply to describe the subject of a work of art by naming what is shown in it—the martyrdom of a saint, a particular episode in history or in a myth, the representation of the ancestors of Christ in the form of the Tree of Jesse—is in that case iconography in a limiting sense only. To go further is to enter into the play of symbolic meanings and how they have been understood, which is commonly termed for distinction's sake *iconology*: typical topics of investigation would then be, beyond who is represented and in what situation, the role of light as symbol of divine grace in the paintings of Jan van Eyck, or the different emblematic images and subjects that are used throughout history to underscore the theme of death.

The distinction here corresponds to the one in semiology between icons and symbols. While *icons* are related to what they represent by virtue of some quality of resemblance of a denotational kind, *symbols* are

related to what they signify in an arbitrary sense only, by virtue of connotations with which they are invested. And if the topic of study embracing both these processes is taken to be the systems of visual signification prevailing in a particular culture and period (rather than the contributions of individual artists), then its pursuit can be extended to non-Western traditions equally, such as the representation of the Buddha in Far Eastern art.

However, as an account of the workings of symbolism, the above definition needs to be extended so as to bring other possibilities than those mentioned into its purview. Critical objections to it as it stands are that it leaves out relationships of analogy and substitution that enable artists to deal in symbolic objects of a made-up kind (as in Bosch's *Garden of Earthly Delights*); to suggest resemblances between things (firescreen and halo, nose or mouth and sex organ); or simply to introduce patterns of gesture or behavior understood as saying something in themselves (the swearing of an oath, the manner in which Judas betrays Christ with a kiss).[2] It also schematizes artificially the processes of apprehension. Today semiology and cognitive psychology deal in their separate ways with the bases on which one arrives at a grasping of meaning that entails the recall of earlier images, built-in references of a special or condensed kind, and a layering of implications. The relationship of this to the processes of identification and recognition in front of pictures or of other types of image (including mental images) remains a moot one. Recognition and identification of a direct kind, as in a child's response to the appearance of a horse, may well serve as a preliminary step toward that apprehension; but it cannot be that they are the precondition of it, in any universal sense applying to all media. The delimitation of a particular branch of study, the iconographic, must therefore have an arbitrary tenor to it if it seeks to separate content from formal organization and presentation for the purposes of analysis, in a way that would hardly be possible if the cultural artifact being considered was a textile, an illuminated manuscript page in its entirety, or a carved stone.

When it was first introduced into critical terminology in the nineteenth century, the term *iconography* connoted a classificatory process of study typologically oriented in scope. Such a usage still survives today in one area, the study of "face masks" in portraiture, which represent distinctive versions of a basic physiognomic structure from which further or

secondary images are then seen to derive. Examples of motifs in art that are simply classifiable, like church screen decorations, would be correspondingly Christian subjects such as the Annunciation depicted in a schematized form; the emblems of saints or emperors; and heraldic devices. The fact that standard elements or features are shown, in these cases, in a changing fashion means that particular instances can be compared and contrasted, according to type, with earlier representations. An extension of the same principle allows for the study of how everyday themes and genres are represented, as in Dutch art of the seventeenth century, and their transformation over time. The idea of a "series" that is entailed here would apply also to artists' self-portraits, whether included in other images of theirs or done for their own sake, and to group portraits such as those of companies or family members. Such examples lead in an obvious way toward psychological or contentual forms of explanation to account for change and development in a particular artist. New stimuli from outside, or new internal sources of inspiration, provide the bases for such explanation.

Iconology has been distinguished from iconography in this century on the grounds that iconology consists of iconography "turned interpretative" so that it goes deeper, "into intrinsic meanings or content."[3] Aby Warburg in reviving the term had explained it as the study and interpretation of historical processes through visual images,[4] and it has been increasingly recognized that such a reading of visual evidence surviving from the past makes for a relationship to ideology as embodied in the conventions and beliefs or assumptions of a society. How should it be possible to trace the fundamental terms of connection here? The standard answer in the art historical practice of iconography has tended to be through texts—a method suited to works of art that were addressed, in the first instance, to learned humanists, churchmen, or members of a court or privileged circle. The work then counts as evidence of a "program," its presumed aim being to communicate in equivalent visual form values read into those texts, or spiritual and intellectual significances found in them, which may be so general that they are independent of period.

But a relationship to ideology can equally be found in gestures, costumes, ornament, or building types. The visual stimuli or cues that the eye receives here are not simply the expressive accompaniment to a pre-

constituted message or embellishments in its rendition (as with an actor going through a familiar speech); they are its communicative vehicles. Structuralists recognizing this (Lévi-Strauss on masks, Barthes)[5] have widened the terms of discussion accordingly to include such purely physical features as the contributions of texture and color, relationships of shape and formal contiguities, as well as overall qualities such as atmosphere and mood. The parallel that this implies to forms of theater or spectacle leads to the idea of a broad-based form of cultural study that focuses on particular performances. Topics such as court masques or the decorations for triumphal entries, David's enactment of a shared spirit of purpose in his Oath subjects, and Goya's responses to the loss of liberty in Spain show how this way of thinking about art in its socially mediated aspects proves true to what Warburg, later in life, had conceived of as the study of "expressive human communication and the transformation of its language."[6]

We move here, in fact, to what is sometimes called *imagery*: namely, subject matter and the way it is presented in visual form. Traditionally this term referred to or included in its scope popular art forms, where the relation of image to text is different from that previously described; more complementary, as in the case of printed images of Luther from the time of the Reformation; or more integrally interactive, as in caricature or the comic strip, in a way that resembles naive art. The subject of study is then not just the occurrence of motifs, but their ordering to make up a form of communicative discourse, so that iconography becomes, as Panofsky thought of it, a way-station on the path to iconology.[7]

Now it is often the case that the scheme of thought underlying images has become obscure and puzzling, and therefore needs to have its rationale revealed through study and put into relation to the circumstances of creation. Insofar as the study of symbolism implies a deciphering of cryptic features, to identify its presence is a learned and sometimes arcane discipline. But there is also a symbolic cast that is present in the choice of images themselves, and the way these choices and the modes of presentation condense or bring into focus beliefs and values. The showing of the Russian soldier in caricature as a monster and the narrative devices of the comic strip may seem quite akin here to Panofsky's favored subjects of study. But there is also a crucial distinction that allies those kinds of image

with rituals and with advertising as forms of cultural expression and persuasion. Insofar as the expressive language used in all three cases is nonprogrammatic in character and the persuasion effected is nonverbalizable apart from the viewing experience itself, a move away from the tenets of iconography is entailed, toward what may be called a visually oriented semiotics. One may work accordingly, in studying the cult of Napoleon, from the premise that its impact can be measured from the sheer number and range of images, and one's sense of it enriched by reference to illustrated biographies and novels and the veneration of mementoes; or the feelings attending the movement of the American frontier westward can be reconstructed from images, in all media, of the railroad and of the tree felled by an ax.

Alternatively, there is a narrower and "contextual" version of iconography that focuses on such factors as the circumstances of patronage, the physical context of a work's display, or the functional adaptations that a work undergoes. The religious, social, and political dimensions that are seen in this way as entering into the creation and apprehension of visual imagery are conducive to what may be thought of as a "reconstruction of intentions." But reconstruction need not be taken here in a delimiting way, as implying a finite set of ideas and purposes, as in the classic definition of iconography. Rather, different meanings to differing audiences, or in differing periods, form part of the identity that is studied. The work of art represents a special kind of cultural object: physically unchanging for the most part, and persisting as a constant through differing approaches to its character. The attempt to recover the said identity must necessarily remain speculative, however systematic methods of recreative description and hermeneutic linkage to external data (such as biography) may have become. From the Early Modern period on, the fact that visual images become generally more private in character opens up the possibility of personal and psychoanalytic readings of the artist's mental and physical processes. These readings are often distinct from ones that the artist would formulate himself or endorse. But it is still possible, within the scope of iconography, to chart on more than one front the artistic response to such an event as the Cold War, or to consider to what extent at a given time different media of expression, such as poetry and painting, parallel one another.

2. Style as a Tool of Interpretation

For art historical purposes, style is characteristically taken as a tool of analysis under a double aspect: on the one hand personal, on the other collective. The reasons for this no doubt stem from the fact that in those cultures most assiduously studied by art historians from the beginning, and especially the world of ancient Greece, the attribution of signal achievements to one named figure or another goes with the sense of a certain creative ethos pervading the products of the culture in its entirety. Style, then, serves both as a convenient device or starting point for setting response going, and as a superindividual explanatory principle.

Personal, or as Wölfflin chose to call it in his *Principles of Art History* (1915) "individual" style consists basically of those traits or hallmarks in the physical make-up of a work of art that provide, like handwriting, a way of characterizing the identity of the person responsible. To this are linked such cognate uses of the term as "in the style of" and "early" (or "youthful") style. But style can also be considered, following Wölfflin, under a national aspect, in terms of what Wölfflin himself defined as the style of "the school, the country, the race" (which is to say, synchronically), and in terms of "period" (that is, diachronically).[1] When the first is being talked of, because the sense of national—and still more of racial—boundaries has become less rigid, one tends to wonder today what essentially is being defined other than broad kinds of cultural preference, and therefore what explanatory power the concept has. When it is period style that is in question, and the use of terms such as "Baroque" or "Rococo" is not simply a matter of convenience for labeling purposes, the problem becomes one, contrariwise, of the perspective from which that period is viewed and given historical embodiment today, as compared to the way this was done in preceding eras or versions of art history.

Put together, those two aspects of the discussion of style provide measures of constancy in artistic language and its performance of descriptive tasks, which reach beyond the individual to the group, and beyond that potentially to some larger cultural entity.[2] They also serve as ways of putting together and grouping under a single descriptive heading particular, identifiable ways of doing things.[3] But while all of this makes style an apt and adaptable tool for classificatory purposes, it is not clear if, so

understood, it either has or is left with any kind of a role for interpretative purposes.

It is intriguing to speculate what would have happened if, from his *Classic Art* (1899) on, Wölfflin had not taken "style" as his key term.[4] Contemporary with the development of Saussurian linguistics, he could have worked out simultaneously synchronic and diachronic modes of analysis in which, if linguistic discourse were used for models, the key terms might have been vocabulary, syntax, grammar, and finally convention or tradition. Personal or individual style can be studied simply as a matter of the vocabulary that the artist exhibits, especially in minor details such as those on which Morelli focused. Syntax corresponds to a collective notion of style; to name features shared as a matter of common usage among all artists of a particular phase it is very general terms that are required. A combination of convention and tradition seems to be the essence of what is at issue in the idea of a national style, as in the discussion of the German or the British character. But the idea of a "grammar," which Wölfflin picked up in his talk of the "optical" possibilities available at a particular time,[5] proves more interesting. To take one of Wölfflin's introductory examples, the synchronic comparison of Dutch and Flemish landscapes of the seventeenth century, it forces out a distinction between those aspects of the presentation of landscape that inform one of basic differences in the landscapes themselves, and those that—like Wölfflin's talk of the baroque avoidance of "classic frontality" (in architecture)[6]—communicate an intention to show things in a certain way that distinguishes the presentation *here* from other preceding or contemporary alternatives.

To be used in the latter way, style analysis requires a longish description, or context of description, and not one marked by the key words used to characterize the collective style of the time. In Wölfflin's *Classic Art,* subtitled *An Introduction to the Italian Renaissance,* the key words come in the last chapter before the Conclusion (pt. 2, chap. 3, "The New Pictorial Form") and they are: repose, spaciousness, mass and size, simplification and lucidity, complexity, unity, and inevitability. In contrast, the book contains a passage devoted to Franciabigio's *Portrait of a Young Man* (Louvre, ca. 1520) that compares it to Andrea del Sarto's portraits and that includes the sentence: "Here the movement is resolved into the expression of a fleeting moment and . . . [compared to the *Mona Lisa,*

which it resembles in the gesture of the right hand laid on the parapet] the grand manner portrait becomes transformed into a study of emotions, of genre-like charm," and the passage ends with remarks on how compared to the "restraint in the expression of feelings" characteristic of the Classic period, especially Raphael, the "sensitive and perceptive" treatment here gives "this pensive portrait . . . a particularly modern air."[7] In other words, the separation from the general run of qualities found in portraiture is what counts here for characterizing purposes, as it would in an unusual or specially inflected bending of grammar.

While that analysis involves synchronic factors, Wölfflin went on to extend the same principle of analysis diachronically, in certain passages of his *Principles*. To cite only two of these, where the context of analysis is broad but the remarks themselves are highly focused, he writes in reference to Titian and Velasquez that whereas one can "cut [a figure of the High Renaissance] out: it will certainly appear less to its advantage than in its old setting, but it does not collapse," the Baroque figure is "bound [in its very existence] to other motives in the picture." And he ends the section on painting with a comparable analysis of a Boucher and a David: "Boucher's nude figure creates a unity of form with the drapery and the other detail appearing in the whole, the body collapses if we take it out of its context. David's *Madame Récamier*, on the other hand, is once more the self-sufficing, independent figure."[8]

What Wölfflin has arrived at here—without perhaps realizing it, or realizing how far it breaks his theoretical scheme—is that it is part of the consideration of style that paintings should be composed in a certain mode that serves to communicate a certain aspect of the subject matter. The mark of this lies, analytically speaking, in the existence of distinct relationships among the component elements of the composition that function among them in the same manner as what are termed "paronymic" relationships in language. As Schapiro puts it in one of his more semiotically focused statements on the subject of style, the work comes to be read correspondingly as a "qualitative whole . . . capable of suggesting . . . diffuse connotations as well [as] intensifying . . . associated or intrinsic effects."[9] To put the point more broadly as it relates to Wölfflin's kind of examples, whether or not one can speak of a corresponding intention as capable of being formulated on the artist's part or on the artist's behalf, the expression of personality in artistic form is inherently

conducive to the setting up of interrelationships in the way the elements are rendered that serve directly as a vehicle for content; or in the case of representational art forms, they can sharpen the way the subject is presented, and in turn serve for analytic purposes as an index of what is special or particular to that presentation. The apprehension of such factors on the viewer's part—made in an interpretative attempt to match the visual effect in words without resorting to mere labels, and from one's own historical perspective, to go back to points made earlier—should properly be seen as falling within the province of style analysis rather than that of iconography, where it might more readily seem to belong according to the theoretical and practical ideas of interpretation current today. Or one might more simply say that style analysis and the study of visual imagery have an area of strong common ground here.

In the case of recent art, unless it moves into that in-between area, style analysis is not likely to prove, beyond a certain point, either adequate or useful. Extreme rapidity of change from year to year or from one group of works to the next makes for this consequence, together with the internal reflexiveness of the developments themselves. But there can be a definite profit in the kind of interpretative turn to the discussion of style that asks, not what twentieth-century artists who draw on the "primitive" have in common, but how the forms and features of primitive art have been apprehended by them from a Western perspective; and what the particular connotations of thought and feeling are that attach to an Expressionist or neo-Expressionist language of shapes and colors.

Notes

Chapter 1: The Rhetoric of Art Historical Writing

1. I am grateful to Vicki Hearne for allowing me to make use of this discussion with her; see her book *Adam's Task: Calling Animals by Name* (New York, 1986), 123. This book evidences how, as a poet and philosopher of the animal world, Hearne attributes character and intelligence to horses; and she writes (letter of January 1988) of finding such perceptions worked into Stubbs's art and being able to "read" his horses accordingly—dislike for Lady Lade and resentment on the part of her mount as source for the faults in the horse's posture and expression, while Eclipse's exuberant energy coupled with intelligence shows in Stubbs's depiction of him, referred to later, as straining forward against the bit.

2. One may cite here the exhibitions of 1951 and 1957 (Walker Art Gallery, Liverpool, and Whitechapel Art Gallery, London); the first public showings, in 1963–65, of the very large collection of Stubbs's paintings acquired by Paul Mellon; the first monograph on the artist's work, Basil Taylor's *Stubbs* ([London], 1971); and finally the catalogue for the exhibition "George Stubbs, 1724–1826" (Tate Gallery, London, 1984)—a reduced version of which, built around Paul Mellon's holdings, constituted the exhibition that we visited early in 1985. Its catalogue, by Judy Egerton, forms both physically and in text length the largest publication on the artist to date.

3. Cited by Constance-Ann Parker, *Mr. Stubbs the Horse Painter* (London, 1971), 19.

4. Cited in ibid., 134–36.

5. Sir Walter Gilbey, Bart., *Life of George Stubbs R.A.* (London, 1898), 125; Appendix C there reprints the entries for the Turf Club catalogue of 1794 referred to.

6. Compare also the discussion and argument about the costumes worn in Stubbs's *Harvesters* and *Reapers* of 1785, following the acquisition of those companion pictures by the Tate Gallery in 1977; John Barrell, *The Dark Side of the Landscape: The Rural Poor in English Painting, 1730–1840* (Cambridge, 1980), 25; Neil McCendrick et al., *The Birth of a Consumer Society: The Commercialization of Eighteenth-Century England* (Bloomington, Ind., 1982), 60–62; Ronald Paulson, "*Hambletonian Rubbing Down*: George Stubbs and English Society," *Raritan* 2, no. 2 (Spring 1985): 38–40.

7. Giorgio Vasari, *The Lives of the Artists, A Selection*, trans. George Bull (Harmondsworth, Middlesex, 1965), 96; the Life closes (104) with the famous story about Uccello's wife trying to get him to come to bed.

8. Eve Borsook, *The Mural Painters of Tuscany* (London, 1960; 2nd ed., Oxford, 1980), 74–79, and "L'Hakwood [*sic*] d'Uccello et la vie de Fabius Maximus de Plutarque," *Revue de l'Art* 55 (1982): 44–51. Her conclusions may be compared in their detail with the fullest preceding treatment of the fresco, that of John Pope-Hennessy, *Paolo Uccello* ([New York], 1950; 2nd ed., 1969), 7–9 and 140–41.

9. Cf. Hayden White, *Metahistory: The Historical Imagination in Nineteenth-Century Europe* (Baltimore and London, 1973), Introduction, esp. 22. The present chapter represents, in a more general way, an attempt to adapt his scheme to the history of art history.

10. Horace Walpole, *Anecdotes of Painting in England*, 4 (printed 1771, released 1780; rev. ed., London, 1827), 133, discussing the painted version.

11. Rev. John Trusler, *Hogarth Moralized*, reprinted as *The Works of William Hogarth . . . with Descriptions and a Comment on their Moral Tendency*, 2 vols. (London, 1831), 1:125–26.

12. *Biographical Anecdotes of William Hogarth; with a Catalogue of His Works* (printed by and for J. Nichols; London, 2nd ed., 1782), 211–12.

13. John Ireland, *Hogarth Illustrated*, 3 vols. (London, 2nd ed., 1793), 1:155–70.

14. *Lichtenberg's Commentaries on Hogarth's Engravings*, trans., ed., and introd. Innes and Gustav Herdan (London, 1966), 167.

15. Friedrich Antal, "The Moral Progress of Hogarth's Art," *Journal of the Warburg and Courtauld Institutes*, 15 (1953): 187, 190n.; cf. his *Hogarth and His Place in European Art* (London, 1962), 72.

16. Ronald Paulson, *The Art of Hogarth* (London, 1975), commentary to pl. 48; *Hogarth, His Life, Art and Times*, 2 vols. (New Haven and London, 1971), 1:397.

17. Lawrence Gowing, in exhibition catalogue "Hogarth," Tate Gallery (London, 1971), 38.

18. Sean Shesgreen, *Hogarth and the Times-of-the-Day Tradition* (Ithaca, 1983), 133–57, esp. 151.

19. See Michael Baxandall, *Patterns of Intention: On the Historical Explanation of Pictures* (New Haven and London, 1985), esp. 118–19 (on Piero's *Baptism*), and the argument of his earlier books, esp. *The Limewood Sculptures of Renaissance Germany* (New Haven and London, 1980).

20. John Golding, *Cubism: A History and an Analysis, 1907–1914* (London, 1959; 2nd ed. Boston, 1968), 89–90; Douglas Cooper, *The Cubist Epoch* (London, 1970), 50.

21. Edward Fry, *Cubism* (London and New York, 1966), 21–22; Roland Penrose, "Picasso's Portrait of Kahnweiler," *Burlington Magazine* 164 (March 1974): 129–30.

22. Compare the discussions of those particular questions by Simon Watney, "Modernist Studies: The Class of '83" (review of Charles Harrison, *Modern Art and Modernism,* and other related writings of his), *Art History* 7, no. 1 (March 1984): 108–9, and Roger Cranshaw, "Cubism 1910–12: The Limits of Discourse," *Art History* 8, no. 4 (December 1985): 476–79. Their arguments are anticipated already in general principle by those of Ernst Gombrich, "How to Read a Painting," *Saturday Evening Post* (July 29, 1961), 20–21, reprinted in his *Meditations on a Hobby Horse* (London, 1971), 152, and Pierre Daix, *Cubists and Cubism* (New York, 1982), 60, which deals specifically with the *Portrait of Kahnweiler.*

23. See the larger discussion of this issue in M. Roskill, *The Interpretation of Cubism* (Philadelphia and London, 1985), esp. 238–39; the comparison of that viewpoint with the one put forward by Baxandall in his *Patterns of Intention,* pt. 2, which deals specifically with the *Portrait of Kahnweiler,* as laid out in detail by David Carrier, "Artists' Intention and Art Historians' Interpretation of the Artwork," *Leonardo* 19, no. 4 (1986); 337–42; and the letter of comments made in response by M. Roskill in the same issue, 359.

24. E. H. Gombrich, *Art and Illusion, A Study in the Psychology of Pictorial Representation* (New York, 1960), 212, 190, 175–78. Further references included in the text are to this publication.

25. Anthony Blunt, *Nicolas Poussin* (New York, 1967); further references included in the text are to this publication. The only review to express reservations at the time of the book's appearance seems to have been that of Richard Wollheim, "Poussin's Renunciations," *The Listener* 80 (no. 2056), August 22, 1968, 246–47.

26. Anthony Blunt, "Poussin's Notes on Painting," *Journal of the Warburg Institute* 1 (1937–38): 344–51.
27. See on this subject Richard Verdi, "Poussin's *Eudamidas*: Eighteenth Century Criticism and Copies," *Burlington Magazine* 113 (September 1971): 513–20.
28. Blunt, *Nicolas Poussin*, chap. 7, 219, 231. Francis H. Dowley, "The Iconography of Poussin's Painting Representing Diana and Endymion," *Journal of the Warburg and Courtauld Institutes* 36 (1973): 305–18, does not specifically dissent from the view that Poussin was a learned artist but, in suggesting that he was more interested in dramatic action than in philosophical symbolism, puts forward a claim as to intention that is more analogous to that of Reynolds.
29. Anthony Blunt, "Poussin Studies XI: Some Addenda to the Poussin Number," *Burlington Magazine* 102 (September 1960): 396–400, commenting on Denis Mahon, "Poussin's Early Development: An Alternative Hypothesis," ibid. (July 1960): 288–303. Mahon's letter of response, "Poussin's Development: Questions of Method" received in turn a brief rejoinder from Blunt, ibid. (October–November 1960): 455–56, 489.
30. Roger Fry, "Some Questions of Aesthetics," in his *Transformations* (London, 1926), 16–18; cf. the essay on "The Seicento" in the same volume for Poussin's "pure design."
31. Anthony Blunt, "The Heroic and Ideal Landscapes of Nicolas Poussin," *Journal of the Warburg and Courtauld Institutes* 7 (1944): 159–68, and see p. x of his 1967 preface. By 1960 publications by other scholars (Haskell and Somers-Rinehart among those who worked directly with Blunt; the Panofskys, Sauerlander, and Costello, who had worked with Friedländer) had begun to give an impression of a larger agreement reflected in turn in Blunt's supporting bibliography.
32. Walter Friedländer, *Nicolas Poussin, Die Entwicklung seiner Kunst* (Berlin, 1914), and see the prefaces to the first and fifth parts of *The Drawings of Nicolas Poussin* (Studies of the Warburg Institute, vol. 5, 1939–1974).
33. E. H. Gombrich, "The Subject of Poussin's Orion," *Burlington Magazine* 84 (February 1944): 37–38, 51. Blunt did not mention Charles Mitchell's preceding article claiming the use of Conti as source material ("Poussin's Flight into Egypt," *Journal of the Warburg Institute* 1 [1937–38]: 340–43), presumably because he disagreed with it.
34. Among younger writers for the *Journal of the Warburg Institute* in those years, one may refer here particularly to Wind, Wittkower, and Gombrich; and to them should be added Meyer Schapiro and Francis Klingender, on the basis of contributions made to the journal later.
35. Anthony Blunt, *Artistic Theory in Italy, 1450–1600* (Oxford, 1940), with

prefatory reference to Antal; "Blake's 'Ancient of Days': The Symbolism of the Compasses," *Journal of the Warburg Institute* 2 (1937–38): 53–63; "El Greco's 'Dream of Philip II': An Allegory of the Holy League," ibid. 3 (1939–40): 58–69.

36. Blunt, *Nicolas Poussin*, 4–5.

37. Ibid., 205.

38. Ibid., 207.

39. Since George Steiner brought up in his discussion of the "Blunt case" in "Reflections: The Cleric of Treason," *New Yorker*, December 8, 1980, 158–95, the idea—or specter—of a special integrity of argument, and of conscience, that high scholarship imposes, especially in the practice of connoisseurship but also in art historical studies more generally, it should be said that the quest for "meaning" formed in fact the apex of the scholarly edifice that Blunt constructed. Connoisseurship and other forms of positivistic study (documentation, source hunting) served as its contributory basis; and this was true equally of Blunt's work on Picasso. Steiner's argument is quoted and effectively endorsed in Barrie Penrose and Simon Freeman, *Conspiracy of Silence: The Secret Life of Anthony Blunt* (London, 1986), chap. 13, esp. 293–95.

40. Blunt, *Nicolas Poussin*, 177.

41. Cf. White, *Metahistory*, 30–31, for this formulation.

42. Gombrich has described in this connection (conversation of July 1984) the suggestion of T. S. R. Boase, as director of the Courtauld Institute, shortly before the war that a handbook for students on iconography be produced. Gombrich and Otto Kurz were to write between them the religious and secular sections; the examples selected for each section were Poussin's *Orion* for mythology, Terborch's *Paternal Advice* for genre, Turner's *Liber Studiorum* for landscape, and Reynolds for allegorical portraits. The introductory texts for each section were written, but the project never materialized owing to complete loss of the files, which were left at the Warburg Institute in London during the war.

43. Gombrich, *Art and Illusion*, 213, 220.

44. Gombrich's review of Charles Morris's book of 1946, *Signs, Language, and Behavior*, in *Art Bulletin* 31, no. 1 (March 1949): 68–73, marks out a transition toward this later viewpoint.

45. Gombrich, *Art and Illusion*, 178.

46. Leo Steinberg, "The Sexuality of Christ in Renaissance Art and in Modern Oblivion," *October* 25 (Summer 1983): 47–48, 93, 114–15, 121–22 (also published as a book).

47. T. J. Clark, *The Painting of Modern Life: Paris in the Art of Manet and His Followers* (New York, 1985), 135–36, 190, 26, 16, 179.
48. Cf. White, *Metahistory*, 31–38, for this categorization and its usefulness.
49. The last three of these definitions are adapted, respectively, from Charles Hartman, "Cognitive Metaphor," *New Literary History* 13 (1982): 334; David Lodge, "Metaphor and Metonymy in Modern Fiction," *Critical Quarterly* (Spring 1975): 75–93, based on Roman Jakobson's 1941 essay "Two Aspects of Language and Two Types of Aphasic Disturbance," in Roman Jakobson and Morris Halle, *Fundamentals of Language* (The Hague, 1956), 69–96, and reused in summary in Lodge's *Working with Structuralism* (London, 1981), 10–11; and Charles Duffy and Henry Pettiet, *A Dictionary of Literary Terms* (Denver, 1952), 121.
50. Blunt, *Nicolas Poussin*, 266–67, 358.
51. I am greatly indebted to Michael Kitson for his advice and comments on this section of the chapter.

Chapter 2: The Study of Imagery and Creative Processes

1. Giorgio Vasari, *Lives of the Most Eminent Painters, Sculptors and Architects*, trans. Gaston DuC. deVere (London, 1912–15), vol. 4, "Life of Piero di Cosimo," 123–34. See, most recently, *Metropolitan Museum of Art Bulletin* (Fall 1983), 46.
2. Erwin Panofsky, "The Early History of Man in a Series of Paintings by Piero di Cosimo," *Journal of the Warburg Institute* 1 (1937): 12–30; reused in *Studies in Iconology, Humanistic Themes in the Art of the Renaissance* (Oxford, 1939), chap. 2, along with his "Piero di Cosimo's 'Discovery of Honey' in the Worcester Art Museum," *Worcester Art Museum Annual* 2 (1936–37): 32–43. Already in an article of the same year as that book, Panofsky took up the matter of accuracy of interpretation in "A Note on the Importance of Iconographical Exactitude," *Art Bulletin* 21 (1939): 402; cf. his comment on the review of *Studies* by Gilbert and Janson, ibid. 22 (1940): 273. His subsequent treatment of R. Langton Douglas's "spirited attack," as he termed it, on his solution to the problem of the Piero di Cosimos (letter to *Art Bulletin* 28, no. 4 [December 1946]: 286–89; replies by Douglas, ibid. 29, no. 2 [June 1947]: 143–47, and no. 3 [September 1947]: 222–23; and a brief rejoinder by Panofsky, no. 4 [December 1947]: 284) foreshadows his similar contestation of Wind's claim in *Pagan Mysteries of the Renaissance* (London, 1958) about Titian's representation of the *Education of Cupid*; see *Problems in Titian, Mostly Iconographic* (New York, 1969), 133 n. 58. However, the close of Panofsky's study of Dürer's *Melancolia I*, first undertaken 1923 and extended

in his *Albrecht Dürer* (1943; 3rd ed. Princeton, 1948), chap. 5, esp. 171, and the later discussion of Titian's treatment of the Salome story and his *Gloria* (*Problems,* 43–46, 70) shows that he accepted in principle the notions of "deliberate obliqueness" requiring inference and "unresolved residues of meaning" that Wind enunciated as a necessary and essential part of the iconographic method in his 1958 Introduction (22).

3. Panofsky, *Studies in Iconology,* 66–67. (The translation from Vasari is Panofsky's own.)

4. See Federico Zeri, "Rivedendo Piero di Cosimo," *Paragone* 9, no. 115 (July 1959): 36–50, and further Everett P. Fahy, Jr., "Some Later Works by Piero di Cosimo," *Gazette des Beaux Arts* 6th ser., 65 (April 1968): 201–12, and Sydney J. Freedberg, *Painting in Italy 1500 to 1600* (Harmondsworth, Middlesex, 1971), 59.

5. Sydney J. Freedberg, *Painting of the High Renaissance in Rome and Florence,* 2 vols. (Cambridge, Mass., 1961), 1:214.

6. Compare Charles Rycroft, *The Innocence of Dreams* (New York, 1979), 50.

7. For the application of those terms to art, see also M. Roskill, "Public and Private Meanings: The Paintings of Van Gogh," *Journal of Communications* 29, no. 4 (Autumn 1979): 157–69, from which this paragraph is adapted, and the very similar discussion by Richard Shiff in his *Cézanne and the End of Impressionism* (Chicago, 1984), 99. The term *symbolism,* it should be noted, covers in principle both aspects of meaning here.

8. See Erwin Panofsky, *Early Netherlandish Painting,* 2 vols. (Cambridge, Mass., 1953), 1:331, on this point. The larger discussion surrounding this passage compares the late works with the preceding ones, 330–45.

9. See Imaginair Museum Hugo van der Goes, exhibition catalogue, Oudercam–Ghent–Leuven, September 1982–February 1983 (with critical bibliography and all the documents), 73–75, doc. 43; translated in W. Stechow, *Northern Renaissance Art 1400–1600, Sources and Documents* (Highland Cliffs, N.J., 1966), 16–18.

10. See, in addition to Panofsky, Friedrich Winkler, *Das Werk des Hugo van der Goes* (Berlin, 1968); Max J. Friedlander, *Early Netherlandish Painting IV, Hugo van der Goes,* trans. H. Norden (Leyden and Brussels, 1969), and Colin Thompson and Lorne Campbell, *Hugo van der Goes and the Trinity Panels in Edinburgh* (National Gallery of Scotland, 1970). A partial exception is R. and M. Wittkower, *Born under Saturn* (London and New York, 1963; New York, 1969), 111–13, which proposes a linkage between Hugo's art (before his breakdown, and as represented by the *Death of the Virgin*) and the beliefs of the Windesheim Congregation.

11. Susan Koslow, "The Impact of Hugo van der Goes's Mental Illness and Late Medieval Religious Attitudes on the Death of the Virgin," in *Healing and History: Essays for George Rosen*, ed. Charles E. Rosenberg (Dawson Science History Pubs., 1979), 27–50.

12. Vasari, *Lives of the Most Eminent Painters, Sculptors, and Architects*, vol. 7, "Life of Jacopo da Pontormo," 147–82 (translation modified for passage quoted).

13. See especially Kurt Forster, "Pontormo, Michelangelo and the Valdesian Movement," in *Stil und Uberlieferung in der Kunst des Abendlandes* (Acts of 21st International Congress for Art History, Bonn, 1964), 4 vols. (Berlin, 1967), 2: 181–85, and Craig Harbison, "Pontormo, Baldung and the Early Reformation," *Art Bulletin* 66 (1984): 324–27.

14. Ignacio Moreno, "Pontormo's Mysticism and the Carthusians," *Rutgers Art Review* 6 (1985): 55–58.

15. Helpful here are G. Nicco Fasola, "Pontormo et Duerer," *Arti figurative* 2 (1946): 31–48, and Janet Cox-Rearick, *The Drawings of Pontormo* (Cambridge, Mass., 1981), 213–26.

16. See Freedberg, *Painting in Italy 1500–1600*, 121–22, for a succinct overview on these lines.

17. C. S. Lewis, *The Discarded Image: An Introduction to Medieval and Renaissance Literature* (Cambridge, 1964), offers a few pages on the subject (63–68).

18. Sigmund Freud, *The Interpretation of Dreams*, trans. and ed. James Strachey, vols. 4–5 of *The Complete Psychological Works of Sigmund Freud* (London, 1953), sec. e, "Representation by Symbolism—Some Further Typical Dreams"; the dates of each section are given there.

19. Sigmund Freud, "Leonardo da Vinci and a Memory of His Childhood" (1910), trans. Alan Tyson, and "The Moses of Michelangelo" (1914, with 1927 postscript), trans. Alix Strachey, ed. James Strachey, in *The Complete Psychological Works* (1953), 11: 59–137; (1955), 13: 211–40 (citing Morelli and his methods at 221). It is interesting to speculate what would have happened to psychoanalytic interpretation of art in general if Freud's procedures had been reversed (they seem in some ways more naturally suited to their subjects the other way round). For criticisms of the two studies, see further Jack Spector, *The Aesthetics of Freud: A Study in Psychoanalysis and Art* (New York, 1972), 53–59, 128–33.

20. See on these two points Charles Rycroft, *Imagination and Reality*, introd. Masud R. Khan and John D. Sutherland (London and New York, 1968), 73, and "D. W. Winnicott" (repr. of review in *New York Review of Books*, June 1,

1972), in his *Psychoanalysis and Beyond,* ed. and introd. Peter Fuller (Chicago, 1985), 144–45.

21. Summarized here are the views of D. W. Winnicott and his follower Masud Khan, and those expressed in the writings of Charles Rycroft, as found especially in his *Psychoanalysis and Beyond.*

22. Rycroft, *The Innocence of Dreams,* 64, 160; "Causes and Meaning," in *Psychoanalysis Observed,* ed. Rycroft (London, 1966), 17, reprinted in *Psychoanalysis and Beyond,* 47.

23. *De somno et vigilia,* bk. 3, translated in Lynn Thorndike, *A History of Magic and Experimental Science,* 8 vols. (New York, 1923–58), 2 (1923): 576–77.

24. See Marjorie B. Garber, *Dream in Shakespeare: From Metaphor to Metamorphosis* (New Haven and London, 1974), 215–17.

25. Philip Goodwin, *The Mystery of Dreams* (1658), cited in *The Oxford Book of Dreams,* ed. Stephen Brook (Oxford, 1983), 174.

26. Responding to Freud early in this century, Roger Fry comes out as an influential opponent of this view, especially when he states in a 1924 lecture (*The Artist and Psychoanalysis,* London, 1924) "Nothing is more contrary to the essential esthetic faculty than the dream" (p. 7).

27. See Walter S. Gibson, *Hieronymus Bosch* (London and New York, 1973), chaps. 3 and 6, comparing German woodcuts of the later fifteenth century.

28. See Millard Meiss, "Sleep in Venice: Ancient Myth and Renaissance Proclivities," *Proceedings of American Philosophical Society* 110 (1966): 348–82, reprinted in his *The Painter's Choice, Problems in the Interpretation of Renaissance Art* (New York, San Francisco, and London, 1976) as chap. 13, 212–40; but he treats Francesco Colonna's *Hypnerontomachia Poliphili* (Venice, 1495) as in effect an iconographic source. I am indebted to Henk van Os for his useful comments on this passage.

29. Gary Schwartz, *Rembrandt, His Life, His Painting* (first pub. in Dutch, 1984; Harmondsworth, Middlesex, 1985), preface, 9, 37, pls. 16–17.

30. Simon Schama, *The Embarrassment of Riches: An Interpretation of Dutch Culture in the Golden Age* (New York, 1987), 122, 149–50.

31. Jeannine Baticle, "Goya et la *Junte des Philippines*," *Revue du Louvre et des musées de France* 34, no. 2 (1984): 107–16.

32. Cited and translated by David Freedberg, "The Origin and Rise of the Flemish Madonna in Flower Garlands, Decoration and Devotion," *Münchner Jahrbuch für Bildender Kunst,* 3rd ser., 32 (1981): 129–30.

33. The phrases quoted come from the Author's Preface, Walter Pater, *The Renaissance: Studies in Art and Poetry,* ed. and introd. Kenneth Clark (1873; London, 1961), 27–28.

34. "Sandro Botticelli" (1870), ibid., 74. The painting likely to have inspired this, now in the Boston Museum of Fine Arts, was then in the collection of Alexander Barker and was given to Botticelli by Crowe and Cavalcaselle (following Waagen, 1857) in their *New History of Painting in Italy from the Second to the Sixteenth Century,* 3 vols. (London, 1864), 2: 421; see Ronald Lightbown, *Sandro Botticelli,* 2 vols. (Berkeley and Los Angeles, 1978), 2: 131, no. C 44 (as School of Botticelli). Pater goes on to the more familiar *Madonna of the Magnificat* in the Uffizi.

35. Kenneth Clark, *The Romantic Rebellion: Romantic versus Classic Art* (New York and London, 1973), 21, 27; the quotations that follow are at 106, 95.

36. Francis Klingender, *Goya in the Democratic Tradition* (London, 1948; New York, 1968), introd. Herbert Read; all page references hereafter are to this edition.

37. Nigel Glendinning, in his account of the book, *Goya and His Critics* (New Haven and London, 1977), 188–95, recognizes that Klingender was not "insensitively political," but groups him under "Racial and Political Interpretations" rather than in his chap. 8, on psychological and pathological ones. He notes the influence of the book in Germany and Russia and its impact also on certain French writers.

38. These biographical details are taken from the memoir by Arthur Elton, introducing the 1968 edition of Klingender's *Art and the Industrial Revolution* (first published in London in 1947 and virtually rewritten by Elton with additional plates from his own collection).

39. Quoted in "The Story of the A.I.A.: Artists' International Association, 1937–1953," exhibition catalogue, Museum of Modern Art, Oxford (1983), compiled by Lynda Morris and Robert Redford, chap. 5, "On Revolutionary Art," 25.

40. Francis Klingender, *Hogarth and English Caricature* (London and New York, 1944). Klingender's treatment of the "moral basis" of Hogarth's art forms an interesting parallel to his view of Goya.

41. Francis Klingender, "Realism and Fantasy in the Art of Goya," *The Modern Quarterly* 1, no. 1 (January 1938): 64–77; *Goya in the Democratic Tradition,* preface, xvi.

42. Klingender, *Goya,* 17, 144–45, 175–77.

43. Ibid., 86, 135–37.

44. Ibid., 220, 89, 90.

45. Ibid., 188. That Klingender attached particular importance to this section of the book is shown in his choosing to publish it in article form: "Notes on Goya's Agony in the Garden," *Burlington Magazine* 76 (July 1940): 4–15.

46. Ibid., 209, 162, 206, 169, 175; letter of Leandro Fernández de Moratin to

Juan Antonio Melón, June 27, 1824, *Obras postumas* (Madrid, 1868), 3: 8, as cited and translated by Eleanor A. Sayre, "Goya's Bordeaux Miniatures," *Bulletin of Museum of Fine Arts, Boston* 64 (1966): 96.

47. Klingender, *Goya*, 210–12; analogous claims of response to oppression (on the private side) and (on the public side) of refashioning one's persona to match the demands of the world dominate the discussion of women's art, on a Marxist model, in the 1980s, the overarching point of contention there being women's place in art history.

Chapter 3: Indeterminacy and the Institutions of Art History

1. The documents and literary sources pertaining to the *Arnolfini Portrait* that are cited below are conveniently brought together in Martin Davies, *The National Gallery*, Les Primitifs Flamands, Corpus II (Brussels, 1954), 125–28.

2. Cf. Dan Sperber, *On Anthropological Knowledge* (Cambridge, 1985), chap. 1, "Interpretive Ethnography and Theoretical Anthropology," 20–21.

3. John Ruskin, review of Charles Eastlake's *History of Oil Painting, Quarterly Review* (March 1848), reprinted in *The Complete Works of John Ruskin*, ed. E. R. Cook and Alexander Wedderburn (London, 1904), 12: 257 n. 1.

4. Erwin Panofsky, "Jan van Eyck's Arnolfini Portrait," *Burlington Magazine* 64 (1934): 117–27.

5. For the privileging of van Eyck and of this painting, see further Panofsky's *Early Netherlandish Painting*, 2 vols. (Cambridge, Mass., 1953) and the review of it by Julius Held, *Art Bulletin* 37 (1955): 215–16.

6. Jan Baptiste Bedaux, "The Reality of Symbols: The Question of Disguised Symbolism in Jan van Eyck's *Arnolfini Portrait*," *Simiolus* 16 (1986): 5–28.

7. Craig Harbison, "The Story of Jan van Eyck's *Arnolfini Double Portrait*," forthcoming in *Renaissance Quarterly*.

8. W. V. Quine, "Truth," in his *Quiddities: An Intermittently Philosophical Dictionary* (Cambridge, Mass., 1987), 214, proposes accordingly that "coherence" and "correspondence" theories of truth present "not rival . . . but complementary aspects" in relation to one another. At the same time what is entailed in the search for truth tends to fall in practice, as J. L. Austin brought out in his "Truth" (1950), *Philosophical Papers*, ed. J. O. Urmson and G. J. Warnock (Oxford, 1961), 98, somewhere in between the observation of a "minimum requirement" (that of matching the available evidence) and the upholding of an "illusory ideal" (that of reconstructing in toto the reality in question). A legalistic view of truth and a positivistic emphasis in historical studies gravitate toward the first of those alternatives; most philosophies of history, and especially those with an "intentionalist" bias, toward the second.

9. Cf. M. Roskill, *The Interpretation of Cubism* (Philadelphia and London, 1985), chap. 5, esp. 200, 203.

10. See John Shearman, "The Logic and Realism of Piero della Francesca," in *Festschrift Ulrich Middledorf*, ed. A. Rosengarten and P. Tigler (Berlin, 1968), 184 n. 5.

11. See Marilyn Aronberg Lavin, "Piero della Francesca's Fresco of Sigismondo Pandolfo Malatesta before St. Sigismund," *Art Bulletin* 56 (1974), 371.

12. See Francesco Lacava, *Il volto di Michelangelo scoperto nel Giudizio Finale* (Bologna, 1925); Charles de Tolnay subsequently claimed an independent discovery during the winter of 1924–25 in *Michelangelo*, vol. 5, *The Final Period* (Princeton, 1960), 118–19.

13. See Leo Steinberg, "The Line of Fate in Michelangelo's Painting," *Critical Inquiry* 6, no. 3 (1980): 423 nn. 11–12, 430 and n. 29, citing *Life*, December 6, 1949, 45, and Redig de Campos, *Il Giudizio Universale di Michelangelo* (Rome, 1964), 39.

14. See, for a suggested reading that embraces all the components, Mark Roskill and Craig Harbison, "On the Nature of Holbein's Portraits," *Word and Image* 3, no. 1 (1987): 15–16.

15. See Dan Sperber, "Apparently Irrational Beliefs," in *Rationality and Relativism*, ed. Martin Hollis and Steven Lukes (Cambridge, Mass., 1982), 149–80, reprinted in revised form as chap. 2 in *On Anthropological Knowledge*, esp. 38–39.

16. See Randolph Starn and Loren Partridge, "Representing War in the Renaissance: The Shield of Paolo Uccello," *Representations* 5 (Winter 1984): 32–65.

17. See David Carter, "Reflections in Armor in the Canon vanderPaele Madonna," *Art Bulletin* 36 (1954): 60–62; according to Panofsky, *Early Netherlandish Painting*, 183 n. 3, the reflection was independently noticed by Howard Davis and John McAndrew.

18. See A. K. Wheelock, review of A. Blankert, *Johannes Vermeer van Delft 1632–1675*, *Art Bulletin* 59 (1977): 440, and *Jan Vermeer* (New York, 1981), 106; also the review of earlier and subsequent interpretations by Peter C. Sutton, in the exhibition catalogue "Masterpieces of Seventeenth Century Dutch Genre Painting" (Philadelphia, West Berlin, London, March–November 1984), cat. no. 118. The discussion of symbolism in Vermeer's work, and especially in this painting, in my book *What Is Art History?* (London and New York, 1976), chap. 7 is in need of revision in that light.

19. This was the work of W. H. James Weale, *Notes sur Jan van Eyck* (London, Brussels, and Leipzig, 1861). See also his *Hubert and John van Eyck* (London,

1908); and with Maurice W. Brockwell, *The van Eycks and Their Art* (London, 1912).

20. Svetlana and Paul Alpers, "*Ut Pictura Noesis?* Criticism in Literary Studies and Art History," *New Literary History* 3, no. 3 (Spring 1972): 451–52, quote the entry for the painting in the National Gallery catalogue (1955, 3d ed. 1968) in order to argue that interpretation is "intended," the capacity for this being assumed in the viewer. The right (or best) fit with external data then gives (or seems to give) the best interpretation. But this does not accord with the essential difference between early statements about the work and modern claims as these have been explored here.

21. For the cleaning of the *Arnolfini Portrait,* reported as being in excellent condition, see Davies, *The National Gallery,* 117, and *National Gallery Catalogues, Early Netherlandish School,* 3d ed. (London, 1968), 50.

22. Erwin Panofsky, "The Friedsam Annunciation and the Problem of the Ghent Altarpiece," *Art Bulletin* 17 (1935): 433–73.

23. Held, "*Artis Pictoriae Amator,* An Antwerp Art Patron and His Collection," *Gazette des Beaux Arts,* 6th ser., 50 (1957), esp. 74–83, revised and reprinted in his *Rubens and His Circle* (Princeton, 1982), esp. 43–50, 56; Zdzisław Kepiński, "Jan van Eyck: 'Małżeństwo Arnolfinich' czy 'Dawid i Betsabe'" ("Arnolfini Couple" or John and Margaret van Eyck as "David and Bathsheba"), *Rocznik historii sztuki* 10 (1974): 119–64, with English summary 157 and n. 44.

24. Cf. the reply to Brockwell's booklet (London, 1952) of Jules Desneux, "Jan van Eyck et le portrait de ses amis Arnolfini," *Bulletin des musées royaux de Belgique* (Brussels, 1955), 128–44. The argument that the portrait is of the van Eycks has since been revived by Jean Lejeune, "Jean et Marguerite van Eyck et le Roman des Arnolfini," *Commission communale de l'histoire de l'ancien pays de Liège, Documents et Mémoires* 11 (1972) and "A propos de Jean et Marguerite van Eyck et du 'Roman des Arnolfini,' " *Bulletin Monumental* (Paris) 54, no. 3 (1976): 239–44.

25. Panofsky, *Early Netherlandish Painting,* 203, n. 3.

26. See the seventy-eight preceding explanations, from 1815 to 1977, that are listed by J. K. Eberlein, "The Curtain in Raphael's Sistine Madonna," *Art Bulletin* 65 (1983): 61–62, and Appendix, 78, along with the ensuing discussion with R. Cocke, ibid. 66 (1984): 327–31. For forms of exegetic interpretation in the case of literature that take up a trajectory lying irremediably "outside" the text to which they refer, see Frank Kermode, *The Genesis of Secrecy: On the Interpretation of Narrative* (Cambridge, Mass., 1979), bringing this out for the Bible; and for the "astonishing independence from

the text" of the "diegetic order" thereby generated, Robert Scholes, *Semiotics and Interpretation* (New Haven, 1982), 112. I am indebted to Norman Bryson for this way of putting this parallel.

27. I draw here on a lecture by John Shearman, Mount Holyoke College, Fall 1983, and also on Catherine King, "The Liturgical and Commemorative Allusions in Raphael's *Transfiguration* and *Failure to Heal*," *Journal of the Warburg and Courtauld Institutes* 45 (1982): 148–59, with earlier references.

28. See Sydney J. Freedberg, "A Recovered Work of Andrea del Sarto with Some Notes on a Leonardesque Connection," *Burlington Magazine* 124 (May 1982): 287–88, together with the letter of Marilyn A. Lavin, ibid. 125 (March 1983): 162, and John Shearman, "The Exhibition for Andrea del Sarto's Fifth Centenary," ibid. 129 (August 1987): 500.

29. See Erwin Panofsky, *Studies in Iconology, Humanistic Themes in the Art of the Renaissance* (Flexner Lectures, Bryn Mawr College) (Oxford, 1939; rev. ed. New York and London, 1972), chap. 5, "The Neoplatonic Movement in Florence and North Italy," esp. 146–47; also his *Problems in Titian, Mostly Iconographic* (Wrightsman Lectures) (New York, 1969), 110–19, 125–26.

30. Cf. the arguments of David Rosand, "*Ut Pictor Poeta*: Meaning in Titian's Poesie," *New Literary History* 3 (1971–72): 527–42, and *Painting in Cinquecento Venice: Titian, Veronese, Tintoretto* (1976; New Haven, 1982), chap. 3, and those of Charles Hope, "Problems of Interpretation in Titian's Erotic Paintings," Università degl studi di Venezia, Convegno di studi, introd. F. Haskell (Venice, 1976), 111–24; *Titian* (New York, 1980), 34–37, 304 (with earlier references); and "Artists, Patrons and Advisers in the Italian Renaissance," in *Patronage in the Renaissance*, ed. G. F. Lytle and S. Orgel (Princeton, 1981), 293–343.

31. See J. A. Crowe and G. B. Cavalcaselle, *Titian, His Life and Times* (London, 1877), 63–65; Jane Nash, *Veiled Images: Titian's Mythological Paintings for Philip II* (Philadelphia, London, and Toronto, 1985); and the review by David Rosand, *Renaissance Quarterly* 39, no. 4 (Winter 1986): 752–55, from which the phrases quoted are taken. For differing views on Titian's imagery and that of his contemporaries, see further Paul Holberton, "Of Antique and Other Figures: Metaphor in Early Renaissance Art," *Word and Image* 1 (1985): 31–58, and Gerald Studert-Kennedy, "Titian's Metaphors of Love and Renewal," ibid. 3, no. 1 (January–March 1987): 27–40.

32. See Jennifer Montagu, "The Painted Enigma and French Seventeenth-Century Art," *Journal of the Warburg and Courtauld Institutes* 31 (1968): 307–35. For the concept of paradox in seventeenth-century northern European art, see, somewhat analogously, David E. Levine's review of William Schupbach, *The*

Paradox of Rembrandt's Anatomy of Doctor Tulp (London, 1982), in *Art Bulletin* 68, no. 2 (June 1986): 339–40.

33. The phrases quoted are, respectively, from Donald Posner, *Antoine Watteau* (Ithaca, 1984), chap. 4, "Fêtes Galantes," 176, and Norman Bryson, *Word and Image: French Painting of the Ancien Régime* (Cambridge and New York, 1981), chap. 3, "Watteau and Reverie," 81.

34. The phrases quoted are from Thomas E. Crow, *Painters and Public Life in Eighteenth-Century Paris* (New Haven, 1985), chap. 2, "Fêtes Galantes and Fêtes Publiques," 63, and from Bryson, *Word and Image*, 82, which includes a stimulating discussion of Watteau's drawings and the way he uses them. See also Linda Nochlin, "Watteau: Some Questions of Interpretation," *Art in America* 73, no. 1 (January 1985): 68–87, reviewing Bryson, Posner, and the Watteau exhibition of 1984–85.

35. Cited and translated by George H. Hamilton, *Manet and His Critics* (New Haven and London, 1954), 134.

36. See for the second of these works Linda Nochlin, "Thoroughly Modern Masked Ball," *Art in America* 71, no. 9 (November 1983): 188–201, and also the contrasting interpretation of John Hutton, "The Clown at the Ball: Manet's Masked Ball at the Opéra and the Collapse of Monarchism in the Third Republic," *Oxford Art Journal* 10, no. 2 (Fall 1987): 76–94.

37. See the entry for this painting by Françoise Cachin, in the exhibition catalogue "Manet 1832–1883," Grand Palais, Paris–Metropolitan Museum, New York (April–November 1985), cat. no. 167, summarizing different lines of interpretation.

38. For the latest discussion of this work (at the time of writing), see Larry L. Ligo, "The Luncheon in the Studio: Manet's Reaffirmation of the Influence of Baudelaire and Photography on His Work," *Arts* 61, no. 5 (January 1987): 46–51, with earlier references. On the role of the gazes in Manet, see further the recent specific discussion of this in Harry Rand, *Manet's Contemplation at the Gare Saint-Lazare* (Berkeley, Los Angeles, and London, 1987), 81–84.

39. Cf. David Carrier's review of differing interpretations of *The Conversation* (ca. 1911), in his *Representations*, forthcoming, and the discussion of Marjorie Perloff with respect to twentieth-century literature, *The Poetics of Indeterminacy* (Princeton, 1981), on which my own definition draws for parallel purposes.

40. See *Defining Modern Art: Selected Writings of Alfred H. Barr, Jr.*, ed. Irving Sandler and Amy Newman (New York, 1986), 69–72, publishing the brochure of August 1929 (three months before the museum opened), "A New Art Museum," and also Sandler's introduction.

41. Alfred H. Barr, *Matisse: His Art and His Public* (New York, Museum of

Modern Art, 1951), 173. Matisse's drawing of the composition in a letter to Charles Camoin of November 1915—see Jack Flam, *Matisse: The Man and His Art, 1869–1918* (Ithaca, 1986), 414, fig. 417—shows six figures to the right of the composition, but there may only be five in the painting.

42. See Sandler, *Defining Modern Art*; and for supplementary biographical information, especially on Barr's problems with the trustees from 1939 to 1944, Margaret Scolari Barr, "Our Campaigns," *New Criterion* 5 (Summer 1987): 23–74. Barr belatedly received his Ph.D. from Harvard University in 1946 (after passing his oral exams in June 1925) by presenting as his dissertation his monograph of that year, *Picasso: Fifty Years of His Art*, based on his 1939 exhibition catalogue, "Picasso: Forty Years of His Art" (issued in four later editions, each revised, the last in 1941), but with a "new and greatly amplified text." The award of the degree was accepted as a formality, and the Matisse volume is dedicated correspondingly to Barr's three teachers, Mather and Morey of Princeton, and Sachs of Harvard. I am grateful to Rona Roob, Archivist of the Museum of Modern Art, for precise information on this subject.

43. To a large extent, Barr left post–1945 American art to the care of Dorothy Miller.

44. There was no specific public then for women's art of the kind that came into being in the 1960s. In the words of Margaret Scolari Barr (letter of November 1987), "the issue of feminism was not [yet] prominent [and] men and women were [considered] primarily as artists." While Barr correspondingly omitted women artists as such from his structural scheme, the record shows that he admired, among Europeans, Sonia Delaunay and Goncharova, and included their work in the museum's exhibitions and collections in the 1930s and 1940s. He also knew and visited Laurencin, Fini, and Dora Maar. I am indebted to Mrs. Barr for writing me on this subject shortly before her death.

45. See Barr, *Matisse*, Preface, esp. 10.

46. Cf. for this principle Barr's "Matisse, Picasso and the Crisis of 1907" (an expanded version of one section of the monograph, i.e., pp. 86–88), *Magazine of Art* 44, no. 5 (May 1951): 163–70, reprinted in *Defining Modern Art*, 192–201.

47. See especially Pierre Schneider, *Matisse*, trans. Michael Taylor and Bridget S. Romer (New York, 1984), and Flam, *Matisse*; and for the writings, *Matisse on Art*, ed. Jack Flam ([New York], 1973), and *Henri Matisse, Ecrits et propos sur l'art*, ed. Dominique Fourcade (Paris, 1972), together with M. Roskill, "Matisse on His Art and What He Did Not Say," *Arts* 49, no. 9 (May 1975): 62–63.

48. On this topic see M. Roskill, "On the Artist's Privileged Status," *Philosophy*

54, no. 208 (April 1979): 187–98, reprinted in Roskill, *The Interpretation of Cubism* (Philadelphia, London, and Toronto, 1985): 204–14.

49. Alfred H. Barr, "A New Museum," *Vogue*, October 26, 1929, 85, 108, reprinted in *Defining Modern Art*, 73–76.

50. John Elderfield's review of Flam, *Matisse*, and Schneider, *Matisse*, "Matisse: Myth vs. Man," *Art in America* 75, no. 4 (April 1987): 16 offers cogent comments on the significance of Barr's contribution here.

Conclusion

1. I have benefited in preparing this Conclusion from the following recent publications: Hans Belting, *The End of the History of Art?* (first published in German, 1983), trans. Christopher S. Wood (Chicago, 1987); *Kunstgeschichte. Eine Einfuhrung*, ed. Hans Belting, Heinrich Dilly, Wolfgang Kemp, Willibald Sauerlander, and Martin Warnke (Berlin, 1986), part 3; *The New Art History*, ed. F. Borzello and A. L. Rees (London, 1986); recent State of Research publications in the *Art Bulletin*, especially Richard Shiff, "Art History and the Nineteenth Century: Realism and Resistance," *Art Bulletin* 66, no. 1 (March 1988): 25–48; the abstracts for the discussion sessions at the College Art Association meeting, February 1988, on Deconstruction and on Marxism in Retrospect; and James Elkins, "Art History without Theory," *Critical Inquiry* 14, no. 2 (Winter 1988): 254–378.

Supplement 1: Iconography

1. Erwin Panofsky, "Introductory," *Studies in Iconology: Humanistic Themes in the Art of the Renaissance* (Oxford, 1939; rev. ed., New York, 1952), 3; reprinted with additions as "Iconography and Iconology: An Introduction to the Study of Renaissance Art" in his *Meaning in the Visual Arts* (New York, 1955), 26.

2. See Robert Klein, *Le forme et l'intelligible* (Paris, 1970), translated by Madeline Jay and Leon Weiseltier as *Form and Meaning: Essays in the Renaissance and Modern Art* (New York, 1979), chap. 8, "Thoughts on Iconography," especially 148–49.

3. Panofsky, *Meaning in the Visual Arts*, 32, 40.

4. Aby Warburg, "Italienische Kunst und internationale Astrologie in Palazzo Schifanoia" (lecture of 1912), *Atti del V. Congresso Internazionale di Storia dell' Arte in Roma, L'Italia et l'arte straniera* (Rome, 1922), 179–93; reprinted in Warburg, *Gesammelte Schriften*, 2 vols. (Berlin-Leipzig, 1932), 2:459–81, and translated by Peter Wortsmith as "Italian Art and International

Astrology in the Palazzo Schifanoia in Ferrara," in *German Essays on Art History*, ed. Gert Schiff (New York, 1988), 234–54.

5. Claude Lévi-Strauss, *La voie des masques* (Geneva, 1975), translated by Sylvia Modelski as *The Way of the Masks* (Seattle, 1982); Roland Barthes, "Rhétorique de l'image," *Communications* 4 (1964): 40–57, translated by Stephen Heath in *Image, Music, Text* (New York, 1977), 32–51, and *Système de la mode* (Paris, 1967), translated by Matthew Ward and Richard Howard as *The Fashion System* (New York, 1983).

6. See Kurt W. Forster, "Aby Warburg's History of Art: Collective Memory and the Social Mediation of Images," *Daedalus* 105 (1976): 176, which draws on a 1923 statement of Warburg's regarding his library, published in E. H. Gombrich, *Aby Warburg: An Intellectual Biography* (London, 1970), 222.

7. See Panofsky, *Meaning in the Visual Arts*, 32.

Supplement 2: Style as a Tool of Interpretation

1. Heinrich Wölfflin, *Kunstgeschichtliche Grundbegriffe* (Munich, 1915), translated by M. D. Hottinger from the 7th German edition, as *Principles of Art History* (New York, 1932), Introduction, 2–10.

2. See Meyer Schapiro, "Style," in *Anthropology Today*, ed. A. L. Kroeber (Chicago, 1953), 287–312.

3. See E. H. Gombrich, "Style," *Encyclopedia of the Social Sciences* (1958) 15: 352–61.

4. Heinrich Wölfflin, *Die klassische Kunst: ein Einführung in die italienischen Renaissance* (Munich, 1899), translated by Peter and Linda Murray from the 8th German edition as *Classic Art* (London, 1952), with introductory commentary on this subject.

5. Wölfflin, *Kunstgeschichtliche Grundbegriffe*, 12–16, as commented upon by Arnold Hauser, *The Philosophy of Art History* (original German ed., Munich, 1958; New York, 1963), chap. 4, "Art History without Names," esp. 121.

6. Wölfflin, *Principles of Art History*, 223.

7. Wölfflin, *Classic Art*, 182.

8. Wölfflin, *Principles of Art History*, 169, 184.

9. Schapiro, "Style," 304.

Index